WHOOSH!
250 WAYS TO GET MOTION INTO YOUR DRAWINGS

*Whoosh! 250 Ways to Get
Motion into Your Drawings*
A QUARTO BOOK

Copyright © 2016 Quarto Inc.

First edition for North America
published in 2016 by
Barron's Educational Series, Inc.

All inquiries should be addressed to:
Barron's Educational Series, Inc.
250 Wireless Boulevard
Hauppauge, New York 11788
www.barronseduc.com

ISBN: 978-1-4380-0724-3

Library of Congress Control
No.: 2014956310

QUAR.FWMD

Conceived, designed, and produced by
Quarto Publishing plc
The Old Brewery
6 Blundell Street
London N7 9BH

Senior editor: Katie Crous
Art editor & director: Caroline Guest
Additional text: Brian Douglas Ahern
Designer: Karin Skånberg
Picture research: Sarah Bell,
 Georgia Cherry
Copy editor: Diana Craig
Proofreader: Julia Shone

Creative director: Moira Clinch
Publisher: Paul Carslake

Color separation in Hong Kong
 by Bright Arts Ltd
Printed in China by 1010
 Printing International Limited

9 8 7 6 5 4 3 2 1

CONTENTS

WELCOME TO MY WORLD

My story with illustrations started when I was about two years old, when I scribbled all over the wall of our house with the crayons that my mother had bought for me. Obviously, this did not make my mother very happy, but it was an indication that I had awakened to a new magical world of infinite possibilities.

Over the years, my interest in animation, games, movies, and music has shaped my personality. But the most striking memory I have of my childhood is comics. Comic artists were my true heroes at that time, and I can remember practicing my drawing like crazy, to try to reach the same level.

ILLUSTRATION IS "THE NEW BLACK"

Not too long ago, illustration was a very competitive area, as there were more illustrators than jobs. However, new and endless possibilities emerged with the digital world, with the increasing demand for e-books, children's books, games for mobile devices, web comics, and even traditional publishers adding digital content to their catalogs. But all of this opportunity comes at a price: You need to stand out among all the others who are also looking for the perfect job. The problem is that many artists fail to convince their audience that their art has its own life and movement—precisely the subject covered by this book.

In these pages, I hope to inspire aspiring artists (working in either traditional or digital media) to give movement to their characters and objects so that they are not only convincing, but also full of life and energy. I deal with the same issues that I faced throughout my professional journey, in order to give you a head-start, including tips about action lines, the use of simple forms, gestures, weight, and framing, and much more. This is the book that I would like to have read when I was starting out.

If, after reading this book, you feel that you have become a stronger illustrator, even more dynamic in your art, and able to stand out in the lucrative market of illustration, my mission will have been accomplished!

CARLOS GOMES CABRAL

"IF I HAVE SEEN FURTHER, IT IS BY STANDING ON THE SHOULDERS OF GIANTS." ISAAC NEWTON

ABOUT THIS BOOK

In its four main sections, this book will guide you through the main concepts and techniques needed to master dynamic drawing—the lines of action in making the gestures of a character, how basic shapes are used to suggest movement, the best positions to heighten the drama in a scene, and, finally, how to tell a compelling narrative with art alone.

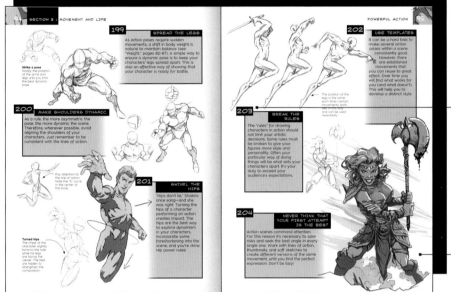

250+ ways
Carlos shares his concise toolkit of expert tips and tricks for getting motion into your drawings.

Artist's drawings
Carlos applies the tips to varied subjects, scenes, and characters, so that you can see art theory in action.

Guest artists
Various artists with different styles take up residence on several pages to share their experience, inspirations, drawings, and methods.

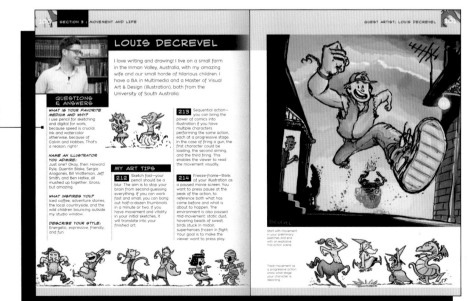

THE HUMAN HEAD

01 BUILD THE IDEAL FACE: FROM THE FRONT

The image reflects our perception of the ideal structure for a human face. Note the guidelines that anchor the main features. First, draw a circle to set the size of the skull and add a vertical center line. Then cut the circle in half horizontally, and draw another line just below. This marks the level of the eyes. The bottom of the circle touches the tip of the nose. The tip of the ear aligns with the top of the eye. Now draw an inverted triangle from the outer edges of the brow line to the center line to find the distance to the chin. Finally, the outer corners of the mouth line up with the center of the eyes . . . and you've got a perfect front view!

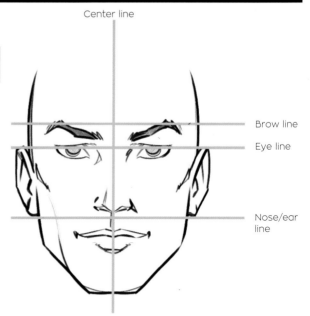

Center line

Brow line

Eye line

Nose/ear line

Matching sides
Everything that is drawn on the left is replicated exactly on the right side. We call this bilateral symmetry.

02 BUILD THE PROFILE

The key to drawing a face in profile is to find the center of the ear. Once located in the skull, this will serve as a guide to the rest: Use the guidelines shown to figure out the placement of the rest of the features, as with the front view.

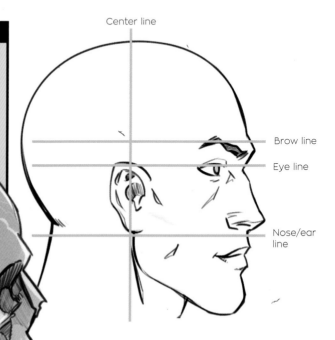

Center line

Brow line

Eye line

Nose/ear line

Underlying bone structure
It's very important to understand the bone structure of the skull beneath the skin to make the features convincing, and for your characters to seem real and alive.

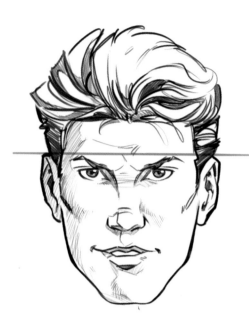

Fleshing out the face
Notice the contouring below the eyes, nose, and cheekbones. This gives dimension to the face around the eye sockets, nasal cavity, and so on.

03 MAKE THE HEAD MOVE

It is relatively easy to draw the basic front-view face using the guidelines, but once you understand how the blocks fit together, you have to be creative to tweak features and retain a realistic look. Here, I tilted the head down slightly: The eyebrows now touch the line of the eyes, and the tips of the ears are at the same height as the brow line. Slight changes like this can make for very interesting results.

04 OPEN THE EYES

Think of the eyes as simple spheres surrounded by eyelids. The eyelids are made of a thin layer of skin that protects the eyes from bright light and foreign objects. The simple movement of opening or closing the eyelids is driven by a single muscle at the top of the eyes, which, in most cases, acts involuntarily.

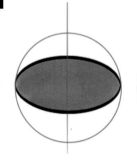

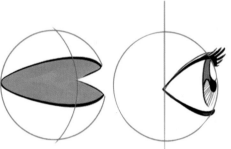

Realistic eyelids
Give a subtle thickness to the lids.

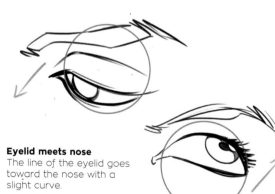

Eyelid meets nose
The line of the eyelid goes toward the nose with a slight curve.

05 DRAW EYES WITH DIRECTION

The secret to drawing eyes with a sense of movement is to get the path of the eyelids right. First find the iris, and draw its curved outline. Then, find the outer corners of the eye and connect them across the eye with sweeping curves to make the lids. Done!

06 MAKE EYEBROWS WITH EXPRESSION

Expressive eyebrows can be daunting, until you see them as a simple line graph (think of the stock market). You might have devoted your entire life to getting eyebrows right, and still not have solved it without that tip. Well . . . not any more, right?

07 KEEP BROWS AS SOLID SHAPES

Don't even think of drawing every eyebrow hair, line by line (although this can work with some cartoon styles). Keep them solid, with a few strokes around the edges to mimic a real eyebrow. Don't overdo it; movement can be implied.

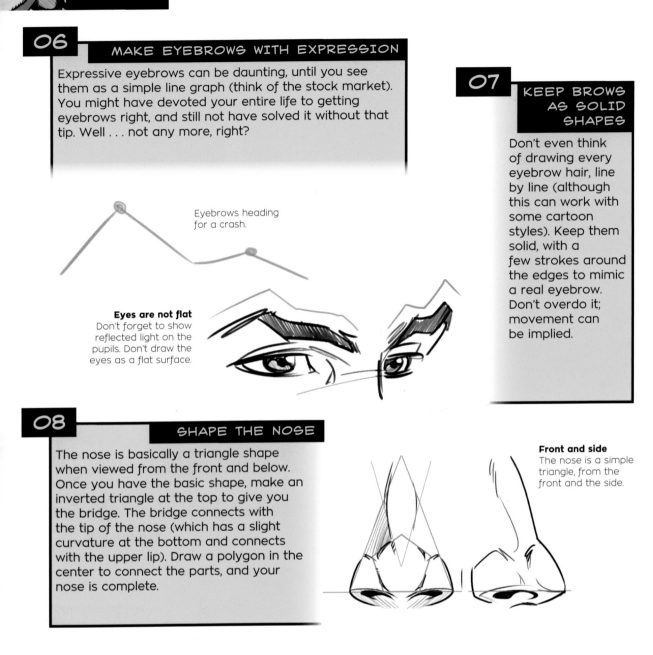

Eyebrows heading for a crash.

Eyes are not flat
Don't forget to show reflected light on the pupils. Don't draw the eyes as a flat surface.

08 SHAPE THE NOSE

The nose is basically a triangle shape when viewed from the front and below. Once you have the basic shape, make an inverted triangle at the top to give you the bridge. The bridge connects with the tip of the nose (which has a slight curvature at the bottom and connects with the upper lip). Draw a polygon in the center to connect the parts, and your nose is complete.

Front and side
The nose is a simple triangle, from the front and the side.

Look at the kidney shape of the nostrils as seen from below.

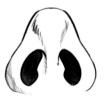

Note how the tip connects with the upper lip.

09 PAY ATTENTION TO THE FEMALE NOSE

The female nose has a less pronounced bridge and smaller nostrils than the male nose. It also tends to be a little thinner and more elegant in general.

10 KNOW THE TRICKS FOR EARS

Ears are one of the most difficult anatomical parts to draw. Fortunately there are some shortcuts that can help! Imagine the ear as being formed of two letter "C"s; a tiny one inside a bigger one. Now, notice how a crooked "Y" connects the two, and voilà! You have a simple ear shape.

Ear trumpet
Imagine the ear as a kind of horn protruding from the side of the head.

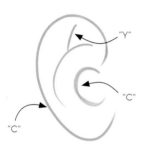

Crooked "Y" between two "C"s

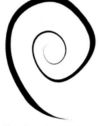

Simple spiral
From the front, you can even reduce the ear to a spiral.

Rotational views of the ear

Front view Back view Three-quarter view

11 THINK OF THE MOUTH AS A BIRD

The easiest way to draw the mouth is to imagine a bird flying toward you. Complete the image by casting a shadow on the ground. That's the basic shape of the mouth; you can fill in the rest with your creativity.

 A bird in flight

Male mouths
Men's mouths are generally thinner, and less detailed than women's.

Female mouths
Note that female lips are more rounded, thicker, and curvier.

Leading lip
The female upper lip sits ahead of the lower lip when viewed from the side.

12 KEEP TEETH OUTLINES MINIMAL

The teeth look better when divisions between them are suggested rather than drawn in slavish detail. Add details as appropriate to the character and the context.

USEFUL TEXTURES

13 THINK OF HAIR AS A FLAT SURFACE

If you think of hair as a ribbonlike flat surface rather than a thicker mass, your sketches will be much more dynamic. Try to imagine a series of ribbons stuck to the head of your character.

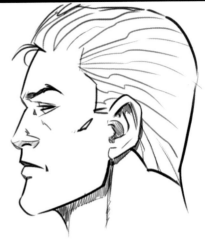

Go with the flow
To draw this short hair I kept the lines going in the same direction, from the front to the back of the head, for a sense of flow and harmony.

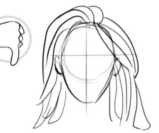

Solid clumps of hair look static and unconvincing.

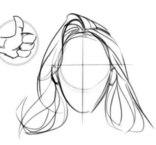

Flat "ribbons" of hair give a sense of movement.

14 AVOID MAKING NOODLE SOUP

Attempting to draw all the lines that make up a head of human hair is not the best way to achieve a convincing result. Instead, draw the overall shape and fill in details as necessary. Make curved lines bold, flowing, and dynamic rather than stiff and lifeless.

15 REMEMBER: THERE IS AN EXCEPTION TO EVERY RULE

In some contexts, such as dreadlocks, hair is permitted to look like noodle soup. To get the effect of dreadlocks, draw a series of long tubes following the same direction and filled in with scribbles. The contrast between light and shadow helps us to "see" how the locks tumble down the character's neck— even the slightest indication of movement can add life to a drawing.

Outline the hair with circular forms

16 DRAW AFRO HAIR AS A TEXTURE

Afro hair texture is very simple: As you cannot see each curl clearly, think of it as an allover texture. Make small, circular scribbles to mark the transition between incident light and shadow.

Keep a high contrast between light and shadow.

17

SHOW REFLECTED LIGHT

Give the hair more life and vibrancy by showing light reflecting from it. As with defining the shape, use flowing lines to follow the direction, drawing lightly, and building up areas of light and shade. These might seem like simple details, but see how the hair flows, as in a breeze or as the woman moves . . .

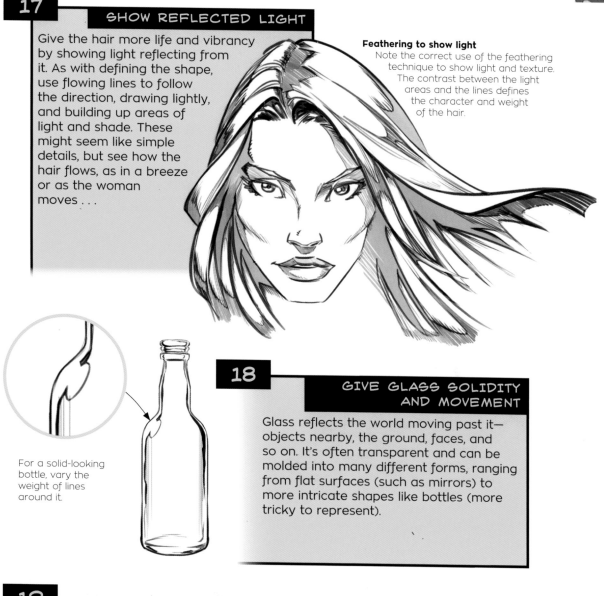

Feathering to show light
Note the correct use of the feathering technique to show light and texture. The contrast between the light areas and the lines defines the character and weight of the hair.

For a solid-looking bottle, vary the weight of lines around it.

18

GIVE GLASS SOLIDITY AND MOVEMENT

Glass reflects the world moving past it—objects nearby, the ground, faces, and so on. It's often transparent and can be molded into many different forms, ranging from flat surfaces (such as mirrors) to more intricate shapes like bottles (more tricky to represent).

19

METAL SURFACES

Generally, metal surfaces are straight and smooth, with a rim light on the edges in contrast with the shadow on the center. A metal sphere can be glossy when its surface has a high shine. Achieve this effect by using a small oval (as a light reflection) on the object in conjunction with the rim lighting.

Open ovals highlight the polished effect of smooth surfaces.

The same approach can be used on other shapes and objects, to create a look of luster or shine.

Guides help you to use perspective to show the movement of a liquid.

The liquid spreads across a flat surface. The shape of the puddle conveys movement.

Use shadows between the liquid and the surface to indicate that this substance is thicker and stickier than water.

Transparency and movement
Water has an extremely reflective texture. To show the transparency of water droplets, draw a fine line in the "corner" of each. The line needs to be in the same direction in each drop.

20 UNDERSTAND THE PHYSICS OF LIQUIDS

Liquids are amorphous and adapt to the shape of any object that contains them, such as a glass, a bottle, or a flat surface. Understand the surface that will accommodate your liquid, as well as how the shape and form of the liquid can denote movement or stagnation.

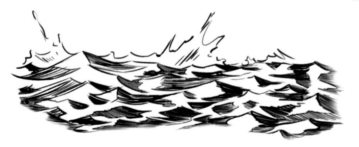

21 SHOW WATER MOVEMENT

Drawing large volumes of water, such as the sea or a flowing river, can be a daunting task. Large bodies of water move when subjected to external factors, such as the direction and intensity of the wind. Pay attention to these factors and be as dynamic as possible, varying undulations of the waves.

Approach waves logically
Use guidelines to mark the movement of the waves. Set the direction and the orientation of the light, and you're good to go.

22 GIVE ROCKS SOLIDITY

To draw realistic-looking rocks and stones, use the contrast between light and shadow to give depth. As they tend to be extremely unevenly shaped, with thickness and weight, shadows are important. Make sure the outlines of your rocks are geometrically imperfect.

Draw tiny strokes toward the light. These short lines suggest imperfect surfaces.

High contrast between light and shadow.

23 DRAW WOOD YOU CAN FEEL

To simulate a wooden surface, draw slightly deviating parallel lines in one direction with some curls between them. Make some small rips on the edges of the timber to suggest tangible fibers in the wood.

A material that looks how it feels adds believability.

24 WEAR IT DOWN

The secret to drawing worn surfaces is to make irregular and sinuous lines, coming mainly from the edges of the material. Show worn surfaces from the effects of environment, and give a sense of carelessness and dirt.

Worn materials communicate repeated handling.

25 USE FABRIC TO SHOW MOVEMENT AND CHARACTER

It's necessary to understand how certain surfaces refract light according to their texture. Light-colored clothes and knit fabrics absorb light differently than more shiny fabrics such as vinyl, for example. Shiny clothes highlight feminine curves, enhancing even further the curved-spine, vixen-like stance of the character shown here.

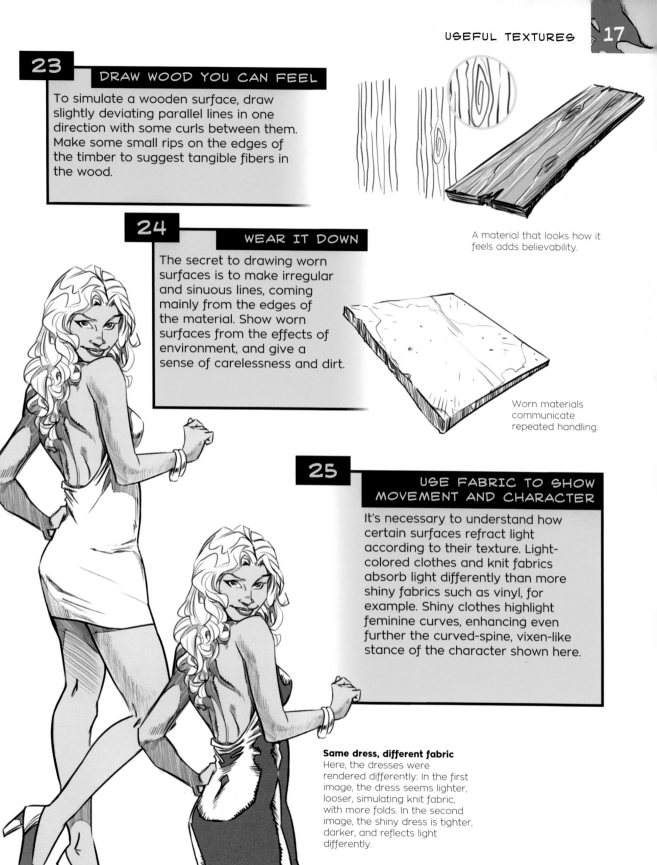

Same dress, different fabric
Here, the dresses were rendered differently: In the first image, the dress seems lighter, looser, simulating knit fabric, with more folds. In the second image, the shiny dress is tighter, darker, and reflects light differently.

WORKING IN LAYERS

26 HOLD YOUR PENCIL THE RIGHT WAY

Every artist finds their own way to hold the pencil, but for larger, more fluid movements try holding the pencil with your index finger and thumb like tweezers, supporting the pencil on the middle finger. It's also important to rest your wrist on the work surface, to avoid tiring your arm.

27 MAKE THE RIGHT STROKE

Always draw in a loose and fluid way. The degree of confidence of an artist shines through in their sketches. (Constant doodling will help you practice.) Be confident throughout the process and try to complete your art using the smallest number of lines possible.

28 WORK GENERAL TO SPECIFIC

Always work from light to dark, from minimal to detailed. If you start out with dark, thick lines and shadow focusing on one small detail, the drawing will turn out smudgy, overdone, lop-sided, and out of proportion.

Minimize lines
If you're making a circle, try to complete it with just a single line. If you make a mistake, draw another complete line above the first. Keep practicing, and you will see your art improve in a very short time.

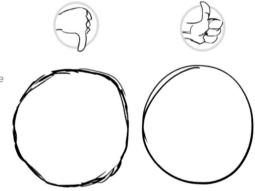

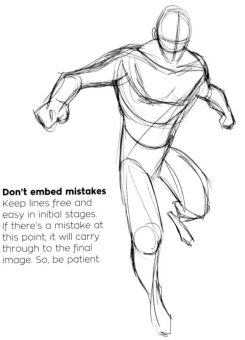

Don't embed mistakes
Keep lines free and easy in initial stages. If there's a mistake at this point, it will carry through to the final image. So, be patient.

29 CAPTURE THE ESSENCE IN YOUR SKETCHES

Before starting any sketch, it's important to understand the essence of what you want to create or reproduce. Don't worry about the details in this early stage. You must be able to develop your design through loose and light strokes. Have no fear, and take risks if you need to!

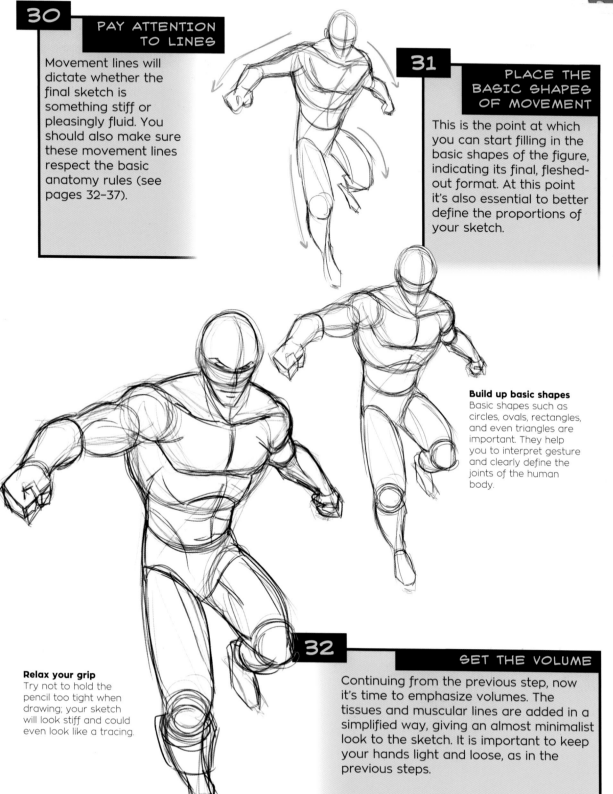

30 PAY ATTENTION TO LINES

Movement lines will dictate whether the final sketch is something stiff or pleasingly fluid. You should also make sure these movement lines respect the basic anatomy rules (see pages 32–37).

31 PLACE THE BASIC SHAPES OF MOVEMENT

This is the point at which you can start filling in the basic shapes of the figure, indicating its final, fleshed-out format. At this point it's also essential to better define the proportions of your sketch.

Build up basic shapes
Basic shapes such as circles, ovals, rectangles, and even triangles are important. They help you to interpret gesture and clearly define the joints of the human body.

Relax your grip
Try not to hold the pencil too tight when drawing; your sketch will look stiff and could even look like a tracing.

32 SET THE VOLUME

Continuing from the previous step, now it's time to emphasize volumes. The tissues and muscular lines are added in a simplified way, giving an almost minimalist look to the sketch. It is important to keep your hands light and loose, as in the previous steps.

The light source here comes from above and casts shadows below the character's body.

33 APPLY SOME LIGHT

At this point you can project a source of ambient light to give weight to the sketch and build visual interest around it—remember that light is responsible for defining the forms (for more about this topic, see page 24).

34 DEFINE AND RENDER

Now it's time to begin to combine all forms, volumes, textures, and shadows in a single drawing. Your lines should still be loose and fluid, but with a little more confidence and richer detail.

Hold the detail
In simple storyboards for movies and animations, this is usually the maximum level of detail that the artist provides.

35 FORGET YOUR ERASER

Try to avoid using an eraser in your first attempts at doodling something. All these steps have a purpose: Setting the basis for a good piece of final art. With practice, you'll start to feel more confident and your brain will know what works for you and what doesn't. For now, experiment without fear and you will succeed.

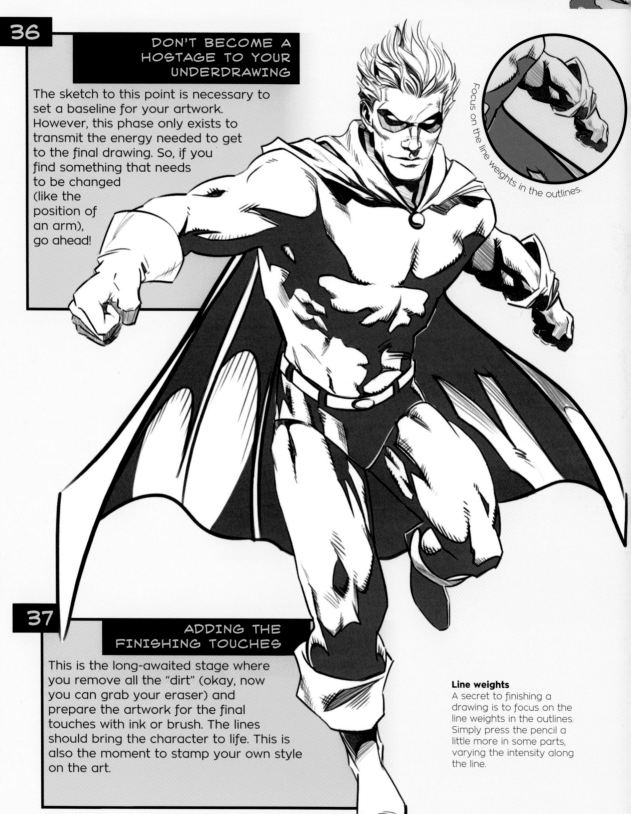

36

DON'T BECOME A HOSTAGE TO YOUR UNDERDRAWING

The sketch to this point is necessary to set a baseline for your artwork. However, this phase only exists to transmit the energy needed to get to the final drawing. So, if you find something that needs to be changed (like the position of an arm), go ahead!

Focus on the line weights in the outlines.

37

ADDING THE FINISHING TOUCHES

This is the long-awaited stage where you remove all the "dirt" (okay, now you can grab your eraser) and prepare the artwork for the final touches with ink or brush. The lines should bring the character to life. This is also the moment to stamp your own style on the art.

Line weights
A secret to finishing a drawing is to focus on the line weights in the outlines. Simply press the pencil a little more in some parts, varying the intensity along the line.

BASIC TYPES OF MOVEMENT

38

RECOGNIZE COMMON MOVEMENT CATEGORIES

By no means the only types of movement, the three movement categories pictured here are quite common and are often seen in many drawings. They are swooping, jagged, and straight motion. Look at a variety of work online and see how many drawings you can identify as being based on these core movements.

The swooping line guides us through a swift Fall wind blowing around dust and dead leaves.

Swooping

39

APPLY SWOOPING MOTION

Swooping motion is usually seen in waves, wind, and majestically flowing capes. The more gradual and lazy the curve, the slower the movement appears to be. Harsh curves indicate high velocity.

Jagged

The jagged path of a lightning bolt is uneven, providing a strong sense of quick motion.

40

APPLY JAGGED MOTION

Jagged motion is associated with harsh and jarring movement, such as bolts of energy or a shockwave.

41 APPLY STRAIGHT MOTION

Straight motion is effective when dealing with speed, or with mechanical objects/vehicles that have rigid movement, such as a bullet or rocket.

Straight motion works just as well for a slow-moving paper airplane as it does for a speeding comet.

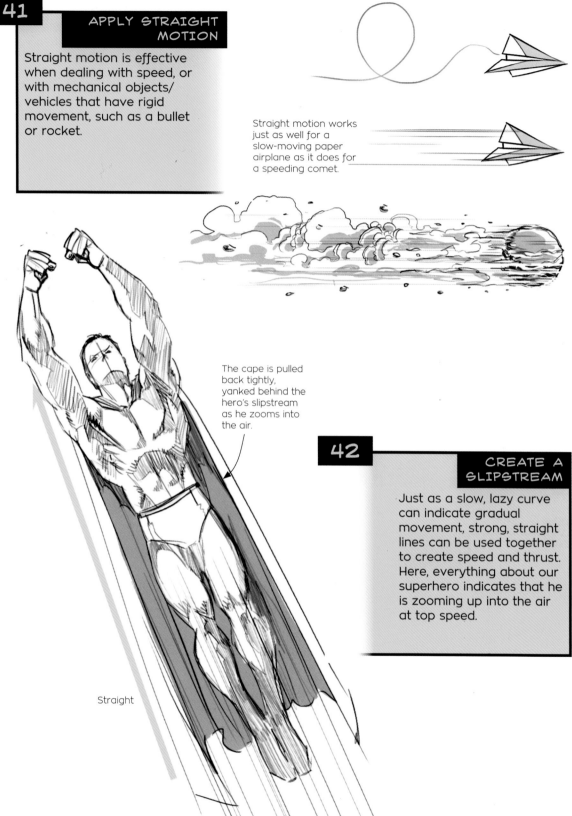

The cape is pulled back tightly, yanked behind the hero's slipstream as he zooms into the air.

42 CREATE A SLIPSTREAM

Just as a slow, lazy curve can indicate gradual movement, strong, straight lines can be used together to create speed and thrust. Here, everything about our superhero indicates that he is zooming up into the air at top speed.

Straight

DEMYSTIFYING LIGHT

43 UNDERSTAND THE ROLE OF LIGHT

Light defines the surface and structure of objects. In art (and life) light is responsible for creating the perception of depth, volume, and texture in everything we see. A circle is just a flat geometric shape. But shine a light on it and it becomes a sphere, giving it a completely new dimension.

44 USE LIGHT EFFECTS

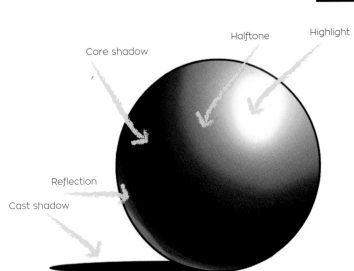

Core shadow

Halftone

Highlight

Reflection

Cast shadow

When we shine a light source on an object, we get four effects: Highlight, halftone, core shadow, and reflected light. The highlight is the part that is most exposed and closest to the light source, which usually means there is nothing to draw because it's completely white! The halftone is the effect caused by the transition between light and shadow (like a grayish tone). The core shadow is the darkest part, which does not receive light directly. Finally, we have the reflection of the surface the object sits on, which faces the shadow it casts.

45 REPRESENT TONES WITH PENCIL

Knowing how to reproduce shapes and tonal variations using only the pencil is essential, especially if you work with an inker. Look at the rendering technique of the two spheres below, and you will clearly understand this point.

Work with perception
Not everything has a smooth surface. The face is made up of many bumps and curves. The rules of light and shadow apply to the face, but in a different way than on simpler objects.

46 SHOW HALFTONES WITH CROSS-HATCHING

Cross-hatching, a technique widely used in comics and character designs, involves drawing many intersecting parallel lines to give objects a sense of volume.

47 INTERSECT CROSS-HATCHING DIAGONALLY

Always try to intersect areas of different parallel lines diagonally to achieve a good transition. Crossing your lines vertically and horizontally to the light source will create an undesirable tic-tac-toe effect.

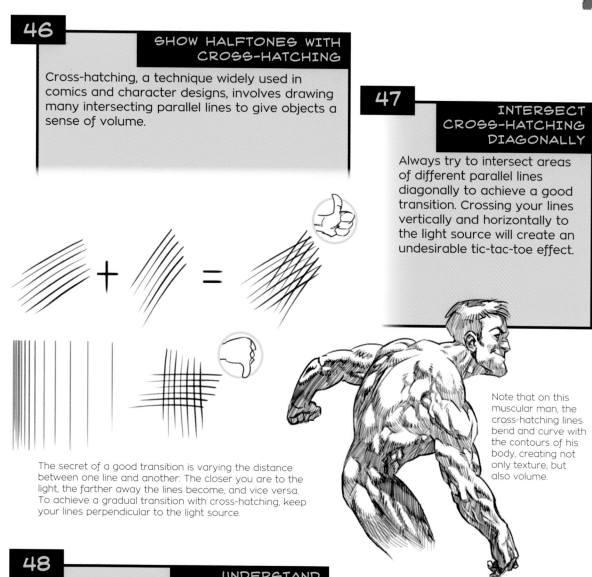

The secret of a good transition is varying the distance between one line and another: The closer you are to the light, the farther away the lines become, and vice versa. To achieve a gradual transition with cross-hatching, keep your lines perpendicular to the light source.

Note that on this muscular man, the cross-hatching lines bend and curve with the contours of his body, creating not only texture, but also volume.

48 UNDERSTAND LIGHT IN MOTION

How does light affect the feeling of motion? As the figure moves, the light moves differently across the surface of the body. With this outstretched arm, we can see the light from above gives us shadows below. Keep in mind studies of muscle groups (see pages 32–37) when you draw. The shadows will follow the surface of each muscle group so that the light creates an uneven pattern, but follows the structure of the arm to highlight each line and curve.

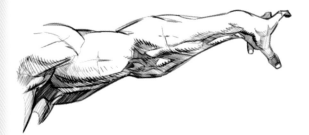

49

USE SIMPLE FEATHERING

Lighting an object that is in a dark environment adds a mysterious, dramatic effect. The feathering technique can be simplified to show just the contrast between blacks and whites, rather than suggesting volume changes.

The outlines, before shading.

Use just a few feather lines in the right spots for the most striking result.

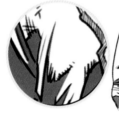

High contrast adds drama
Even when the outlines are removed, the brain is capable of "completing" the drawing. This is a sign that the lighting effect has been applied correctly.

50

CAST A SHADOW

Cast shadows are flat, and are created when an object blocks a light source. The positions of cast shadows are vital to indicating movement and motion. If the character or object is moving, so is the shadow. Where that shadow falls, and how, tells us a lot about who or what is moving.

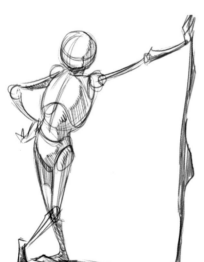

Here the shadow connects the character, the ground surface, and the wall.

51

LEARN TO DEAL WITH DIFFERENT LIGHT DIRECTIONS

It's not enough to know theories of light and shadow; you need to be able to apply them to different angles. Remember that the choice of the light source angle is not just down to personal preference; it depends on the context of the story being told. Strong patterns of light and shade can exaggerate or enhance a sense of movement.

Using light to shape the face

If you remember when we talked about the nuances of the human skull (see pages 10–13), this is the time to put that knowledge to the test: The secret is finding the protruding parts of the face, such as ears, nose, cheekbones, and eye sockets, and seeing how they can block the light from reaching other parts of the face.

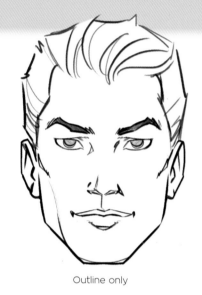

Outline only

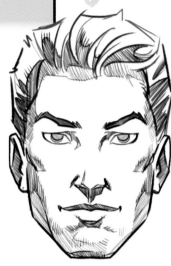

Top lit

Lit from right

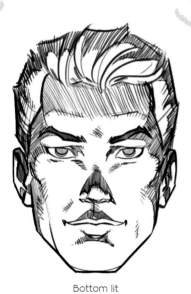

Bottom lit

Lit from back-left

Reflection on right

EASY PERSPECTIVE

52
DON'T MISTAKE THE HORIZON FOR THE FLOOR

One of the biggest mistakes beginners make is to think that the horizon is the same as the floor. It is not: The horizon line is the eye level, or how far your sight can reach. The horizon is often associated with the floor because, in general, you can think of it as the line that separates the earth from the sky. The horizon is also the line from which the vanishing points emanate.

53
DRAW ONE-POINT PERSPECTIVE

In one-point perspective there is only one vanishing point, which is responsible for giving a sense of depth to all objects in the scene. One-point perspective is the method usually used when drawing hallways, tunnels, railroad tracks, and so on. It's the simplest perspective method and, as a result, the most widely used.

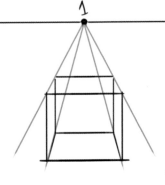

Horizontals and verticals
With this method you can see that the horizontal and vertical lines remain horizontal and vertical.

One-point perspective of a hallway.

54
DRAW TWO-POINT PERSPECTIVE

Take the box drawn in the previous example and rotate it so that one of its corners is at the center. Here there are two vanishing points; the concept of perspective is applied in two directions rather than just one.

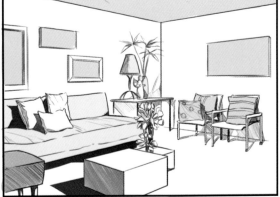

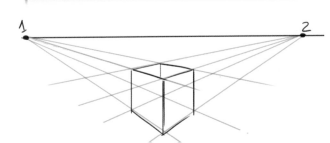

Verticals
In two-point perspective the vertical lines remain vertical, while the "horizontal" lines now go toward the vanishing points.

Two-point perspective of a room interior.

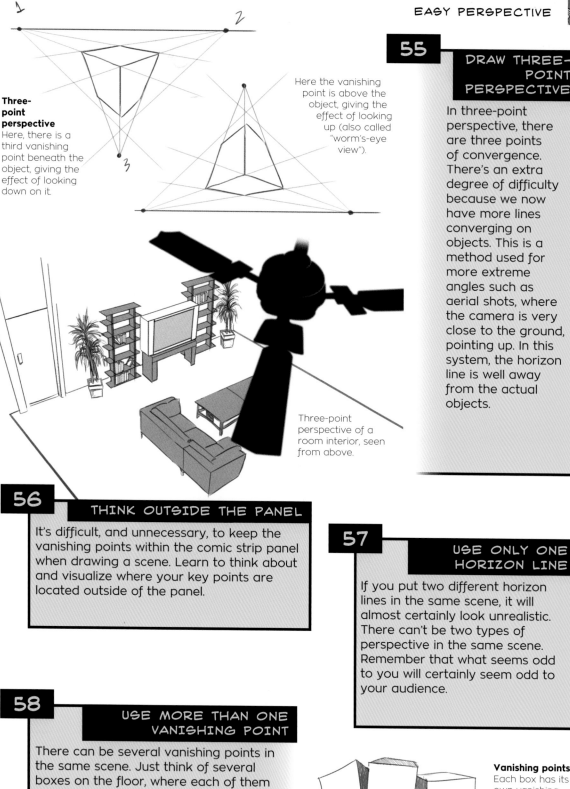

1 **2**

Three-point perspective
Here, there is a third vanishing point beneath the object, giving the effect of looking down on it.

3

Here the vanishing point is above the object, giving the effect of looking up (also called "worm's-eye view").

Three-point perspective of a room interior, seen from above.

55 DRAW THREE-POINT PERSPECTIVE

In three-point perspective, there are three points of convergence. There's an extra degree of difficulty because we now have more lines converging on objects. This is a method used for more extreme angles such as aerial shots, where the camera is very close to the ground, pointing up. In this system, the horizon line is well away from the actual objects.

56 THINK OUTSIDE THE PANEL

It's difficult, and unnecessary, to keep the vanishing points within the comic strip panel when drawing a scene. Learn to think about and visualize where your key points are located outside of the panel.

57 USE ONLY ONE HORIZON LINE

If you put two different horizon lines in the same scene, it will almost certainly look unrealistic. There can't be two types of perspective in the same scene. Remember that what seems odd to you will certainly seem odd to your audience.

58 USE MORE THAN ONE VANISHING POINT

There can be several vanishing points in the same scene. Just think of several boxes on the floor, where each of them has a different size and position.

Vanishing points
Each box has its own vanishing point, but they share the same horizon line.

59

DRAW ACCURATE INTERVALS

To accurately achieve repeating elements in perspective drawing, such as tiles on a floor, or columns in a hallway, use crisscross lines to divide spaces equally. Where the lines cross is the halfway point between them (see the "birds-eye view" and the perspective, right).

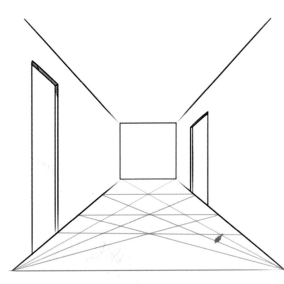

Placing dividers
The point where the lines converge (the center of the "X") is where you should place the horizontal divider.

60

MOVE A PERSON IN PERSPECTIVE

To move a person toward or away from the camera within a panel, you need to establish where eye level is. For instance, if your eyes (or the horizon line) are at waist level this means that, no matter how near or far that person moves, their waistline will always remain at the same level. You will need to make adjustments for varying sizes of characters in the same scene.

Eyes at shoulder height
Here, there are people closer to the viewer and further away, but their shoulder height is always at eye level.

61

USE BODY SIZE TO MEASURE DISTANCE

When dealing with a horizon line that lies well above the characters (also called "bird's-eye view"), you cannot draw them all at the same level. Instead, use the character's own body height to determine how far away from the horizon the character should be.

Horizon line

Use figures to calculate
When seen from above, the distance between the characters and the horizon is calculated using the actual size of their bodies.

62

DRAW TRICKY SCENARIOS

There are some situations in which the application of the basic rules of perspective will not be as effective. When you're drawing natural elements, for example, you will have to use some freehand techniques to achieve the desired results. Obviously, some perspective rules will still apply, but in a less formal, measured way.

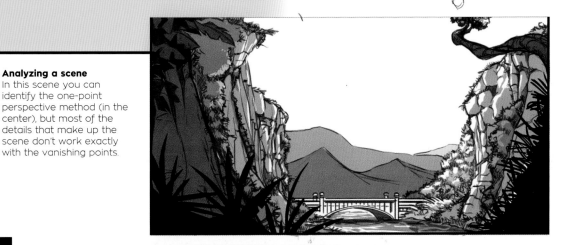

Analyzing a scene
In this scene you can identify the one-point perspective method (in the center), but most of the details that make up the scene don't work exactly with the vanishing points.

63

SEE PERSPECTIVE FOR WHAT IT IS

Perspective is only a tool to help in the construction of scenes or to place figures and objects in relation to others to create a sense of depth. Perspective isn't the way humans actually see. Therefore some rules must be broken (wisely, of course) in order to create an image that is pleasing to the eye. In fact, if you try to find perfect perspective rules in photographs, you'll be disappointed! Use your imagination more than the ruler.

THE BASIC FIGURE

64 UNDERSTAND CONSTRUCTION

When you start drawing the human figure you must understand its four main parts: Head, ribcage, pelvis, and limbs. These parts need to be connected harmoniously and must work together in order to create gestures and movements that are convincing to the viewer. You can represent all the parts of the body with basic shapes such as circles, rectangles, triangles, and curved lines.

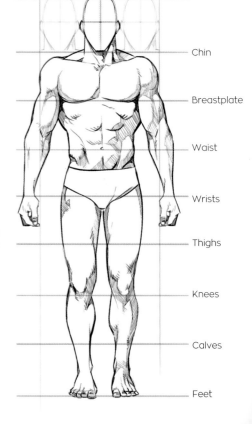

The four main parts of the human body shown by different shapes.

65 KNOW BASIC PROPORTIONS

The adult human measures about eight heads high. Each dividing line marks a specific part of the body. The distance between the shoulders is three heads. Think of these measurements when drawing the human figure.

66 PRACTICE DRAWING PROPORTIONS

It's important to memorize the basic rules of proportion of the human body. This way you will avoid a rigid design based on guidelines. Practice as much as you can so you don't have to measure things out whenever you draw a new character.

Chin

Breastplate

Waist

Wrists

Thighs

Knees

Calves

Feet

67 STUDY THE SPINE

The human skeleton is designed to balance the weight of the body. The spine is responsible for maintaining this balance, and drives the gestural movements of the torso and limbs. A fluid, working spine adds both life and zest to any drawing.

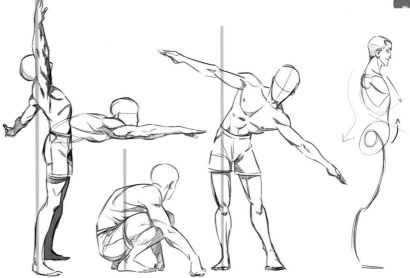

The spine influences the movement of the entire body. The center line of the figure establishes the balance of the body according to the movement.

The spine is represented by an "S" curve—the bottom of the ribcage meets with the upper part of the pelvis. The legs also make a natural "S" curve to support the body weight.

68 STUDY THE TORSO

A variety of muscles make up the torso. The six predominant blocks are: 1—Traps, 2—Pecs, 3—Lats, 4—Serratus Anterior, 5—Abs, 6—Obliques. The torso muscles can be the hardest parts to draw in terms of shapes and curves. Practice them as much as possible.

69 VARY THE ARRANGEMENT OF MUSCLES

In real life, people have different shapes and arrangements of muscles—even when the amount of muscle is approximately the same. Play with muscle configurations to convey realism and movement in your characters. Aesthetic appeal may be more important than anatomical accuracy.

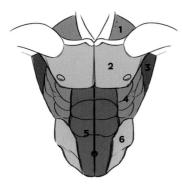

The shoulders (1) sit on top of the pecs (2). The lats (3) start on the back and become apparent in front of the body.

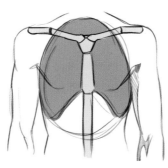

The front view of the spine together with the collarbones looks like the front view of a bicycle.

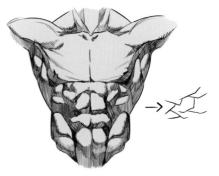

Try to make your lines asymmetrical. Bodies often look more believable when they are built with variations in line.

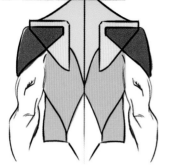

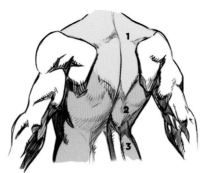

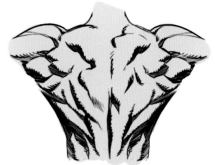

This is a simplified back: There's a triangular bone between the shoulders and the other muscles. The traps start behind the neck and hit the middle region of the back, in a kind of star shape.

The major muscle groups of the back are also noticeable on the front of the body: 1—Traps, 2—Lats, 3—Obliques.

Compressed muscles of the back of a muscular man: Some based on real anatomy, others made up. Be creative with your interpretation of reality.

70 — STUDY THE BACK

The back is an extremely flexible part of the human body (and, for some reason, is overlooked by many artists). When we move the shoulders forward or backward, depending on the intensity, the back muscles squeeze and stretch in such a way that its structure is sharply modified.

71 — OVERLAP THE MUSCLES

The muscles change in shape partly depending on the behavior of neighboring muscles (and the intensity of their movement). Imagine muscles as very elastic tissues that overlap each other.

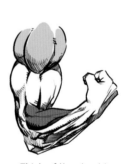

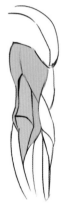

The arm:
1—Deltoids (shoulders),
2—Biceps and
3—Triceps (middle region),
4—Carpi and Flexors (forearm).

Think of the shoulders as three eggs connected to each other. Apply this idea to other areas, too.

The arm from behind: Notice how large the triceps is, wrapping the elbow at the center.

The shoulder follows the movement of the arm when it extends. Tissues are interconnected and overlap each other.

72 — LOOK AT THE STRUCTURE OF THE ARMS

You don't need to know all the muscles that make up the arm (or any part of the body), only the main ones. Once you understand the underlying structure of the arm, the muscles follow.

73 LOOK AT THE STRUCTURE OF THE LEGS

The leg muscles are quite different from those of the arms: They are longer, larger, and, usually, more subtle in terms of definition. The great challenge of the legs is understanding the bone structure in conjunction with the muscles.

The knee divides a leg in half. The bone above the knee is called the femur; the lower one is the tibia.

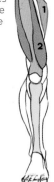

Leg muscles: 1—Adductor, 2—Quads, 3—Glutes, 4—Hamstrings, 5—Calves. The adductor is a pipelike muscle that cuts the leg diagonally to the knee. The quads resemble teardrops and the calves resemble juggling claves that connect the knee to ankle.

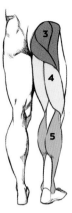

Gender differences
Among other differences, women have thinner-looking necks (an illusion, due to the size of the traps), and the legs appear bigger due to the shape of the hips.

Simplified female
By working with simpler shapes you can build the basic forms of the female figure with ease.

74 RECOGNIZE MALE/FEMALE DIFFERENCES

Women have more sinuous and rounded lines than men, who should be drawn with more straight lines. Paying attention to other anatomical differences will help you to draw women, such as the prominent collarbones, the belly button positioned below the waistline, the breasts positioned below the male pectoral line, and so on.

75 PAY ATTENTION TO FEMALE FORMS

If you look closely, you'll notice that lots of parts of the female body are rendered differently in order to make the forms more aesthetically pleasing and plausible to the viewer. For instance, the hip bones are higher, the obliques are longer, the lats are thinner, and so on.

Muscle similarity
There are not many differences between male and female musculature.

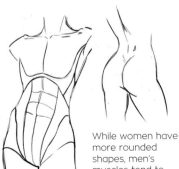

While women have more rounded shapes, men's muscles tend to look squarer and more pronounced.

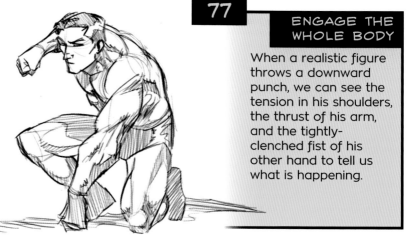

76 CHANGE YOUR ANGLE, CHANGE YOUR SPEED

Presenting your figure at a dramatic angle has a pronounced effect on his perceived movement. A pole vaulter rushing forward is interesting enough, but drawing him from a very low angle combines pose and foreshortening (see pages 74–77) to create a sense of tremendous speed and urgency.

77 ENGAGE THE WHOLE BODY

When a realistic figure throws a downward punch, we can see the tension in his shoulders, the thrust of his arm, and the tightly-clenched fist of his other hand to tell us what is happening.

78 CONVEY TENSION THROUGH POSTURE

Here, we see the beginning of a fight sequence, and there is dynamic tension visible even before a punch has been thrown. Notice how the figures' shoulders lean in toward each other. This slight sense of movement, combined with their tense postures, already implies an impending conflict.

The shoulders lean in toward one another in a physical sign of aggression.

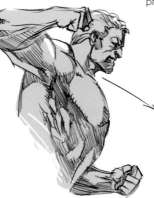
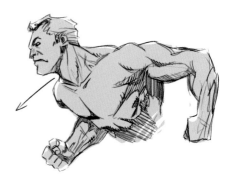

79
USE MUSCLE PROPULSION

A running figure already conveys a sense of quick movement. By staying mindful of how the muscles of the body work together—how the arms and legs will move, tense, and bend—you can enhance your figure from one in a mere trot to someone racing athletically for the finish line!

80
MAKE THE LIMBS FOLLOW THE SPINE

See how this athletic figure bounds backward over a high-jump bar. The curve of the spine indicates both movement and a certain grace in its flexibility. But that's not all that's moving—notice the arms and legs. As the figure makes his leap, the limbs will stretch or bend in response. In any dynamic pose, when the spine moves, the rest of the body follows suit.

81
USE SHADOWS TO REINFORCE POSITION

Outstretched arms contrast with bent legs to tell us this character is upward-bound. Use shadow to emphasize that your character has left the ground.

LAURA BRAGA

Hi, I'm Laura Braga, an Italian comics artist and illustrator. I attended the International School of Comics and the Disney Academy. My first professional work was in 1999 as a storyboard artist for TV commercials. I then worked as a comic book artist, illustrator, and colorist for various international publishers. In 2005, I met and collaborated with Milo Manara, whose influence led me to a more realistic style. Currently I'm working for Marvel Comics and DC Comics.

QUESTIONS & ANSWERS

WHAT IS YOUR FAVORITE MEDIUM, AND WHY?
My favorite medium is paper and pencil. Due to time constraints of work and deadlines, I mainly work in digital, but paper (sketchbook, drawing pad, or Moleskine) and a soft pencil remain my first loves.

NAME AN ILLUSTRATOR YOU ADMIRE:
There are lots of contemporary illustrators that I admire; not to offend anyone I will mention one that is gone. He summarizes what I think of as "Art" with his studies, research, and design intentions: He is Michelangelo Buonarroti.

WHAT INSPIRES YOU?
Life inspires me every day; every little thing that we live should give us a hint, an idea to create something new. My main source of inspiration is my son.

DESCRIBE YOUR STYLE:
My style has changed a lot over time and I think it's still evolving. I think every artist has their own style, and I think the personal style of an artist shouldn't be crystallized in a form that doesn't change over time, but is something that is constantly evolving as a result of study, experience, practice, and other influences. I like to think that my style is the fruit of my life experiences.

Use muscle definition to convey strong limbs.

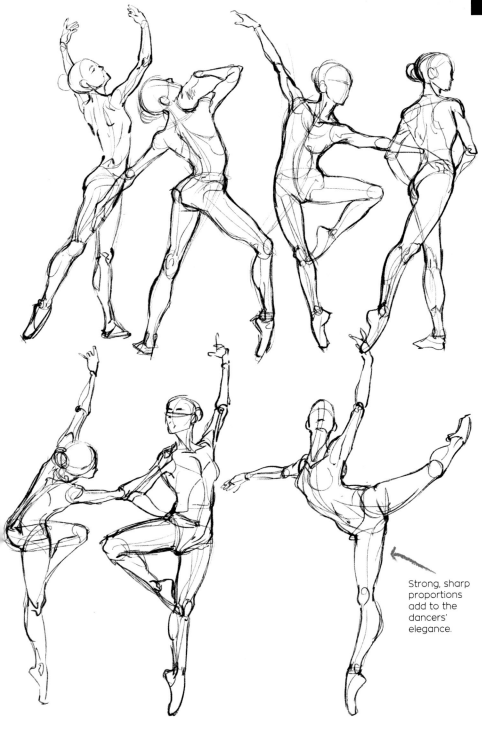

Strong, sharp proportions add to the dancers' elegance.

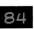

MY ART TIPS

82 Considering that everyone has their own way of working, their tricks, and their favorite tools, and that consequently there is not a technique more correct than any other, my advice is not to set limits and to try any working tool, technique, or style.

83 Also, I still think that study and practice have a huge importance in the work of an illustrator or cartoonist. Among the most important things are drawing as much as possible, reading lots of different comics, observing the world around you, and being curious.

84 Anatomy is very important in my studies. I think it is critical to properly depict a scene, and it's a great way to convey the emotion and mood of the characters we are drawing.

LAURA BRAGA CONTINUED

85 Dancers are associated with smooth, graceful movement. We may want to draw them with only lazy, swooping lines without realizing that we're forgetting what an athletic activity dancing can be. I aim to show the strength of the dancers' arms and legs without diminishing their grace.

86 When adding props, such as for the gymnasts shown right, it's essential that the body moves around them realistically, so that they are incorporated fully into your drawings. Again, real-life study and observation of the anatomical figure in motion are at the core of my work.

Note the outstretched arms and bent knees and elbows. How many triangular shapes can you count among them? How many straight lines?

The poses shown here are amazingly athletic, but they are still realistic.

Note the use of dynamic hands (see pages 88–91), particularly when featured in conjunction with props.

This series of figures conveys elegance and poise. When we see the easy curve of the spine, we tend to overlook the rest of the body's tension.

DENNIS JONES

I'm Dennis Jones, a freelance illustrator from the U.S. My artwork has been commissioned for comics, games, books, toys, bibles, cards, newspapers, wall coverings, and a host of other products. I am probably best known for bringing biblical characters and stories to life—a talent which earned me the Platinum Book Award and fans around the world for my original "Read With Me" Children's Bible.

QUESTIONS & ANSWERS

WHAT IS YOUR FAVORITE MEDIUM, AND WHY?
At the beginning of my career I loved to paint, and gouache (opaque watercolor) was my favorite. Over the years, technology advanced and Adobe Photoshop is now my medium of choice.

NAME AN ILLUSTRATOR YOU ADMIRE:
I enjoy looking at the artwork of J. C. Leyendecker. He was a popular illustrator in the early 20th century and had an art style that was very unique.

WHAT INSPIRES YOU?
Browsing the Internet. I see so many gifted artists from around the world creating fabulous artwork, and it motivates me to try a little harder in my own work.

DESCRIBE YOUR STYLE:
When I was young, I loved Marvel Comic artists John Buscema and Neil Adams as well as Mort Drucker and Jack Davis from *Mad* magazine. I was a fan of political cartoonist Jeff MacNelly and *Asterix* artist Albert Uderzo. I suppose my art style is an odd mix of those various influences.

I start drawing in the middle of the page and let the picture develop in any direction it wants to go.

MY ART TIPS

87 When I draw on a small piece of paper, I either run out of room or my picture looks stiff because I'm trying to make everything fit into a tiny, restrictive space. For that reason, I always use the largest paper (or sketchbook) I can find. I start drawing in the middle of the page and let the picture develop in any direction it wants to go.

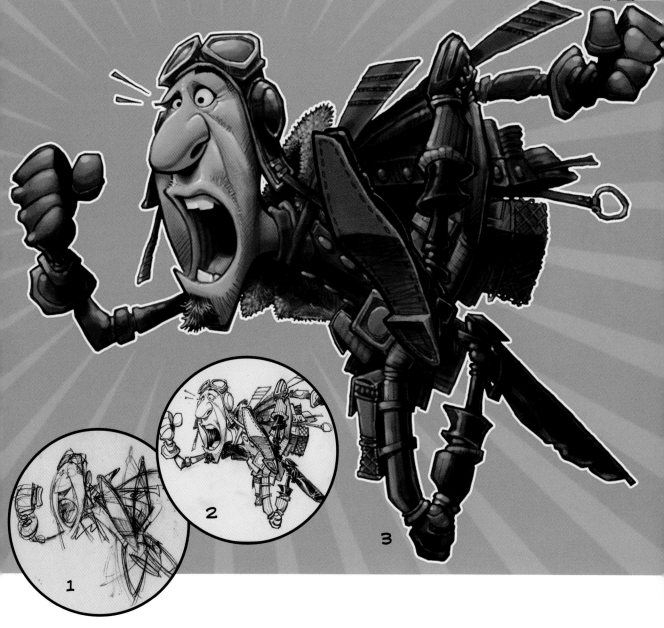

88 I start a picture using an erasable blue pencil, specifically, a Prismacolor Col-Erase 20044 Blue (1). I can't explain why, but beginning in blue makes the sketching process easier for me. I work fast, keep things loose, and concentrate on shapes rather than fine details. This helps me to capture energy in my drawing.

89 I place my blue sketch on a light table, lay another piece of paper over the top of it, and create a tight, finished pencil drawing (2). This is the part of the process where I work out the fine details of my illustration.

90 The final part of my process is scanning the pencil drawing into Photoshop and adding color to it (3). Digital coloring is fun, but I have found that if I start that process with a bad drawing, my finished artwork usually ends up being less than I had hoped for. The extra effort you spend on the pencil drawing is never wasted time.

MASTERING EXPRESSIONS

91 CONNECT THE PIECES

Expressions result from the combined tensing and relation of many opposing sets of muscles. This is what makes faces so compelling to look at—and so difficult to draw. If an eye is opened, this movement changes other facial elements, and vice versa. Also bear in mind that expressions don't just change for each situation and emotion, they move in order to do so.

A coherent face
Don't treat the face like a set of individual elements. Facial muscles work in unison.

92 SHOW BASIC EMOTIONS

Emotions are expressed based on stimuli, and may be involuntary. The following primary emotions are universal: Happiness, anger, fear, and sadness. There are also two more primary emotions, which are variations on the first group: Disgust and surprise.

Happiness

Anger

Fear

Sadness

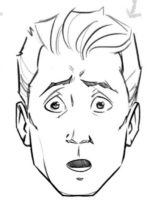

Disgust

Surprise

Variations
The disgust expression is a variation of anger; surprise is a variation of fear.

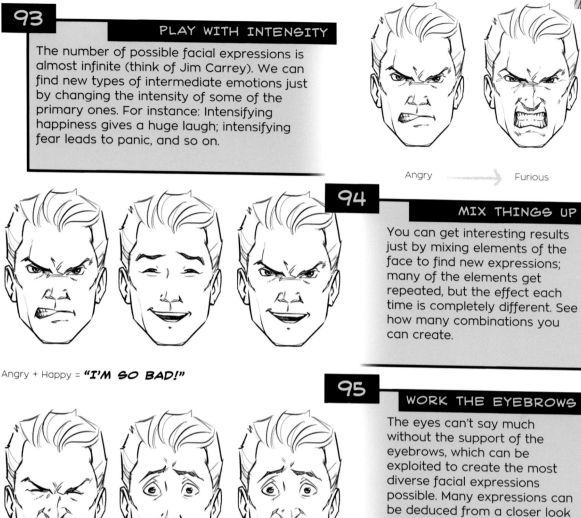

93
PLAY WITH INTENSITY

The number of possible facial expressions is almost infinite (think of Jim Carrey). We can find new types of intermediate emotions just by changing the intensity of some of the primary ones. For instance: Intensifying happiness gives a huge laugh; intensifying fear leads to panic, and so on.

Angry ⟶ Furious

94
MIX THINGS UP

You can get interesting results just by mixing elements of the face to find new expressions; many of the elements get repeated, but the effect each time is completely different. See how many combinations you can create.

Angry + Happy = *"I'M SO BAD!"*

95
WORK THE EYEBROWS

The eyes can't say much without the support of the eyebrows, which can be exploited to create the most diverse facial expressions possible. Many expressions can be deduced from a closer look at the eyes and eyebrows, without the need to show the whole face.

Disgust + Surprise = *"YIKES, I SWALLOWED MY PENCIL!"*

96
EXPRESS MOVEMENT THROUGH EXPRESSION

When considering facial expressions, remember that the face changes its expression and appearance because it moves. The more movement in the features, the stronger the expression. The more exaggerated the expression, the more intense the emotion being indicated.

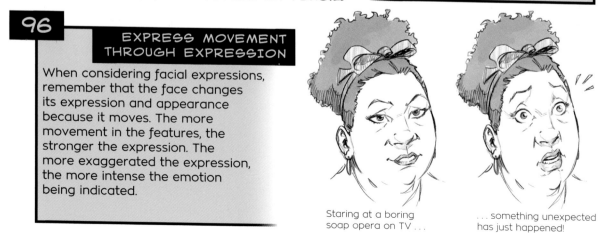

Staring at a boring soap opera on TV . . .

. . . something unexpected has just happened!

97 MIMIC EMOTIONS

We can mimic universal expressions at will, and even add stylistic features to make fun of other people. Comedians and theater actors are among the people who can do this most easily.

"THIS IS HOW TO LOOK SEXY...LET ME SHOW YOU."

98 CONTAIN THE FEELINGS

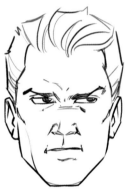

Barely concealed anger.

When we are not comfortable showing our feelings, we are required to restrain them. This causes small changes in facial expressions, which should be reproduced in a subtle way. Remember that even if a character intends to hide an emotion, the viewer is the only one who should be aware of this.

Range of expressions
Emotions such as pain can result in many different expressions, depending on the intensity. Here, you can see a mixture of mild discomfort and surprise.

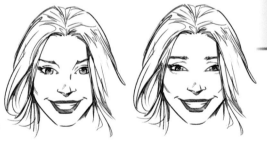

99 SMILE WITH THE EYES

It's common to find people who look exactly the same in every photograph. The reason is simple: They smile falsely. A real smile shows feeling and is reflected in our eyes. Remember that in the face everything is interconnected.

Real or fake?
The first smile is clearly false while the second is real—the eyes are half-closed. Now you can tell a real smile from that of a phony.

100 SHOW THE PHYSICAL STATE

Expressions that reflect a physical state can be unpredictable. Whenever we are confronted by physical factors over which we have no control, facial expressions are involuntary and may merge dozens of other types of expressions. However, many remain recognizable regardless of culture or age.

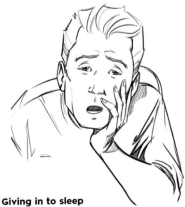

Giving in to sleep
Tiredness is a physical state of expression that we may struggle against, and over which we have little control. A sleepy face may mix sadness with surprise.

101 PLAY WITH THE CONTEXT

You can use irony and sarcasm to deceive and surprise the viewer, who seeks to understand a character's intentions. For instance, a psychopath might issue a cold threat with a smile. The viewer's understanding of the scene will depend on the contextual information you provide.

"OOH, THANKS FOR THE COMPLIMENTS!"

102 TILT THE HEAD

Symmetry is important when you want to convey unity and accuracy, but can lack dynamism. Often you can give a character a more interesting expression by tilting his head, for example. Try to use asymmetry for a more realistic look.

"BUT, UNFORTUNATELY, I WILL HAVE TO KILL YOU"

103 ADD AN ELEMENT

Often you can enrich an expression by adding a single complementary element to strengthen its context. (This will also often strengthen the message you are trying to convey; think of the sweat on the face of a tired athlete.)

104 USE SYMBOLISM

Use of symbolism is a practical way to convey a clear message about the personality, intention, or state of your characters. It's a technique widely used in cartoons—reinforcing an expression or emotion through the use of metaphor.

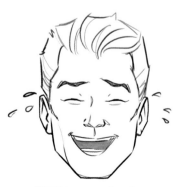

Teardrops spurting from the eyes can indicate a good belly laugh.

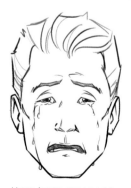

Here, tears are used to strengthen the feeling of sadness.

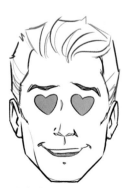

What could more effectively represent love than hearts?

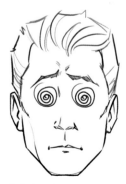

Spirals in the eyes show that this character is being hypnotized.

BODY LANGUAGE

105 STRENGTHEN THE FACIAL EXPRESSION WITH THE BODY

The body needs to work as a unit; a single organism that captures any kind of emotion we feel and translates it into instantly recognizable movements. So, the body of your character is a reflection of his/her facial expression and vice versa.

A simple but recognizable stance can be all you need to express discontent.

106 TALK WITH THE BODY

Our emotions are usually expressed first on our face, followed by our body. But in many cases, the body speaks for itself—through hand movements, the position of the head, or even just the curvature of the spine. Body language is vital in showing movement, as without it, the figure just stands there like a lamp post. The body moves in order to convey its language of gestures.

"NICE DAY TO TAKE A NAP BESIDE THE POOL!"

"ARE YOU TALKING TO ME???"

107 SIMPLIFY YOUR STYLE, EXPRESS YOURSELF

It's common to hear artists lament that they have no difficulty drawing the human figure, but find it hard to express movements, gestures, and emotions. If you worry incessantly about the technical details, it's likely that all of your drawings will end up with the same look. Remember that many artists have a very simplified style, but their drawings are lively, bold, and dynamic as a result. That's how you want your drawings to be.

"I WON, I WON!!!"

"OH, MY... I'M SO SCREWED!"

Practice showing body language
You must be able to use the movement of the body to convey different emotions. Practice making the emotion easily recognizable through outline gestures.

"THINK, MAN...THINK!"

108 LEAD THE VIEWER INTO YOUR WORLD

When you create a scene with a well-defined context, you must lead the viewer into your world, making them feel the same way as your characters. This requires drawing the characters' bodies responding properly to the correct stimuli. Notice here how the bad guy goes toward the target while the victims move away from the life-threatening object.

Leaning away from the perceived danger.

High contrast between light and shadow is used on the bad guy to enhance the composition and readability of the scene.

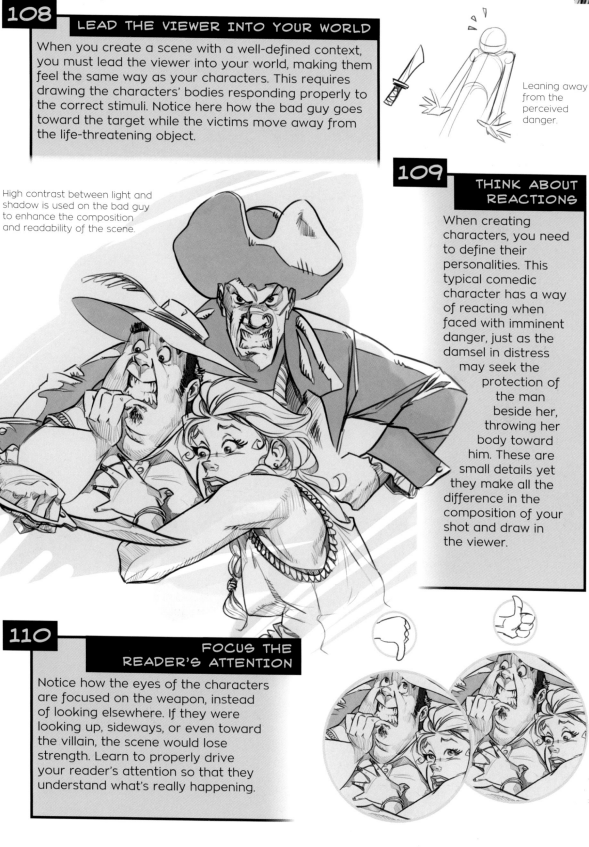

109 THINK ABOUT REACTIONS

When creating characters, you need to define their personalities. This typical comedic character has a way of reacting when faced with imminent danger, just as the damsel in distress may seek the protection of the man beside her, throwing her body toward him. These are small details yet they make all the difference in the composition of your shot and draw in the viewer.

110 FOCUS THE READER'S ATTENTION

Notice how the eyes of the characters are focused on the weapon, instead of looking elsewhere. If they were looking up, sideways, or even toward the villain, the scene would lose strength. Learn to properly drive your reader's attention so that they understand what's really happening.

111 CONTEXTUALIZE THE REACTION

Even when we are facing an imminent danger, our senses make us react in different ways, according to the context of the situation. For instance, it's common to run away from a fire, while we would hold a static pose with our hands raised in front of us to face down an armed thug, if afraid that he'd shoot the gun.

Fire! Run away from it!

Facing an animal: One wrong move and you die!

Stick 'em up! The victim looks ready to back away.

112 CONVEY EMOTIONAL DISORDER THROUGH ASYMMETRY

The movement shown in your drawing need not be greatly exaggerated to be effective. When showing characters under emotional distress, remember that a small gesture of imbalance can go a long way to convey what you want. Movement has a starting point, and often those points are shown subtly. Nobody leaps about with exaggerated poses and gestures all the time. Even the most pronounced movement has to begin somewhere.

The curve of one arm works with the extension of the other to indicate that while the movement is slight, the boy's concern may be considerable.

Our figure here appears to be moving very little. But we have the indication of movement as this pensive character looks ready to start pacing as he organizes his thoughts.

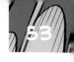

113

CONVEY CONFIDENCE THROUGH SYMMETRY

Just as the imbalanced pose can convey a sense of concern, a balanced pose can convey confidence. The best way to represent this artistically using body language, is to make use of symmetry when drawing characters.

The classic heroic pose always conveys a sense of strength and confidence. The symmetry of this static pose implies a hero is about to spring into action.

This expansive gesture gives us the sense that the character has just extended his arms, so the motion is implied. From here, this fellow could be describing his evil plan, making a political speech, or giving a sales pitch on why his shoe polish is the best in the land.

Raised chin, menacing look

Protruding chest

114

SHOW WHO'S THE BOSS

Just as there is a hierarchy to be respected in the animal world, some people have a natural tendency to subordinate those in a lower position. This occurs when a tall person intimidates a short one, when a strong man challenges a weak one, or when a boss uses his/her position to oppress his/her employees, and so on.

Hands behind the back (or on hips)

115 CONVEY DISINTEREST THROUGH GESTURE

Being somewhere that you don't want to be, or with an annoying, boring person is uncomfortable, and makes us want to get away as fast as possible. There are easily recognizable gestures that signal this common situation. Even the slightest movement in posture and eye direction can convey a lot to the reader.

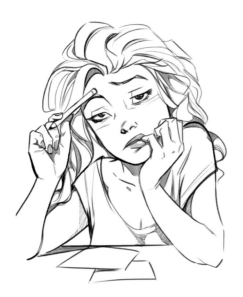

Clearly bored
This bored girl doesn't appear to be moving, but the pose, with the pencil against her forehead, combined with her expression, makes it easy to imagine her tapping the pencil on her brow as the minutes tick slowly by.

A tale of two dates
In these two examples of a couple in a diner, we see two distinct stories. Above, the forward gesture of the figure on the left indicates he is attempting to engage his companion, whose slumped posture and eyes directed at her phone, show she couldn't be less interested.

116 SHOW WHO'S UNDER CONTROL

Just as feelings of victory, conquest, pride, and self-esteem are related to a perfectly balanced body and an upright stance, so defeat, shame, shyness, and humbleness can be graphically portrayed by a hunched body. This is why teenagers are often portrayed looking down, with a stooped posture; they may not yet feel ready to face the challenges of adulthood.

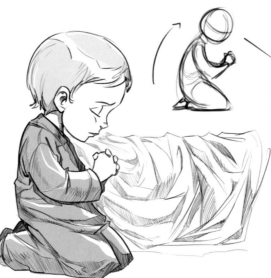

Submission
The act of kneeling with the head down is a symbolic representation of submission, worship, prayer, thankfulness, or respect.

117 CONVEY INTEREST THROUGH GESTURE

Just as we express our dislike of a situation, so we also have ways to indicate that someone or something has captured our attention.

118 UNDERSTAND THE SPACE BUBBLE

Notoriously, we act cautiously around those we don't know well, maintaining a safe distance from them and keeping them outside our bubble. With family or friends, the bubble shrinks, leaving us open to accepting a touch, a hug, or another sign of affection. Compare the two examples of a date in the diner, left, and how the space between the figures lessens as the interest grows.

This second example shows the figure on the right matching her companion's forward-leaning posture, showing an intense interest in their exchange. Two vastly different outcomes indicated by only the slightest change in movement.

119 BREAK THE BUBBLE

When we let someone invade our virtual protection zone, we become vulnerable and may be captivated by the intense feeling that this intimate contact can stimulate. There are several ways to represent this graphically, although they vary according to the characters' motivations, intentions, ages, and the stage and nature of the relationship. Keep one thing in mind, though: Love is universal.

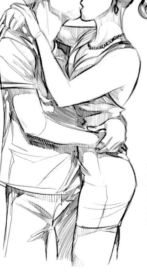

A young couple in love embrace tightly so that their personal bubbles include each other while showing shared affection.

A child astride her father's back and shoulders inhabits her father's space bubble, showing familial affection and joy.

DESIGNING CHARACTERS

120 BE CONSISTENT

Consistency means being able to draw your characters from different angles while retaining their main features. Before you put your character in motion, make sure that the viewer would be able to recognize him in a crowd or from any possible viewpoint. The process of drawing a character from a range of different angles is called "turnaround."

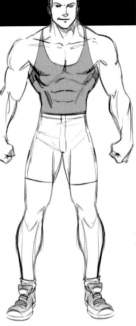

Start your "turnaround" figure with a front view.

121 CONSIDER ANGLES

At a three-quarter angle the character presents a half-front view and a half-profile view. Again, you need to make sure these views are consistent with the features of your character. For example, when the head moves up and down, it doesn't change its size—it's only the position of the facial features that change.

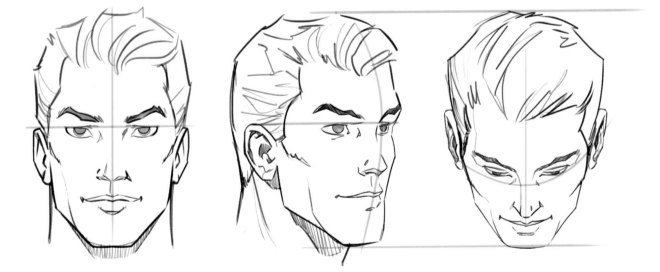

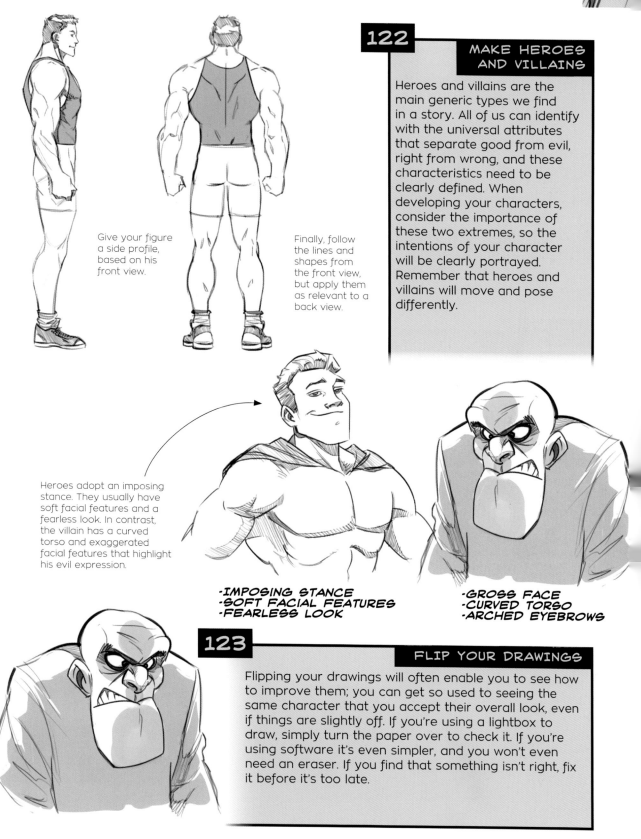

Give your figure a side profile, based on his front view.

Finally, follow the lines and shapes from the front view, but apply them as relevant to a back view.

122

MAKE HEROES AND VILLAINS

Heroes and villains are the main generic types we find in a story. All of us can identify with the universal attributes that separate good from evil, right from wrong, and these characteristics need to be clearly defined. When developing your characters, consider the importance of these two extremes, so the intentions of your character will be clearly portrayed. Remember that heroes and villains will move and pose differently.

Heroes adopt an imposing stance. They usually have soft facial features and a fearless look. In contrast, the villain has a curved torso and exaggerated facial features that highlight his evil expression.

- IMPOSING STANCE
- SOFT FACIAL FEATURES
- FEARLESS LOOK

- GROSS FACE
- CURVED TORSO
- ARCHED EYEBROWS

123

FLIP YOUR DRAWINGS

Flipping your drawings will often enable you to see how to improve them; you can get so used to seeing the same character that you accept their overall look, even if things are slightly off. If you're using a lightbox to draw, simply turn the paper over to check it. If you're using software it's even simpler, and you won't even need an eraser. If you find that something isn't right, fix it before it's too late.

124 ADD VISUAL DISTINCTION

Adding visual distinction to your characters helps build their personalities, which enables the viewer to identify with them more easily. Animator Richard Williams said "Put the opposites together: The big with the little, the fat with the thin, the old with the young, and so on . . ." You'll be exercising your creativity and establishing a more powerful storyline.

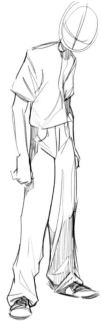

"PUT THE OPPOSITES TOGETHER: THE BIG WITH THE LITTLE, THE FAT WITH THE THIN, THE OLD WITH THE YOUNG, AND SO ON...."

125 DRAW PEAR-SHAPED BODIES

A concept made famous by Disney animators is that of "pear-shaped bodies" (or "bean-shaped bodies") to act as a blueprint for building bodies in cartoon style. This technique is based on the idea of weight (see pages 82–87) and the use of simple geometric shapes. One of the reasons for the use of this technique in cartoon studios is because teams of artists must maintain the correct proportions of each character. By having a simple shape to build on, the process is made easier.

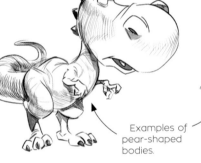

Examples of pear-shaped bodies.

Pear shapes make perfect goofy or chubby characters.

Add character
Props make your characters more recognizable and memorable.

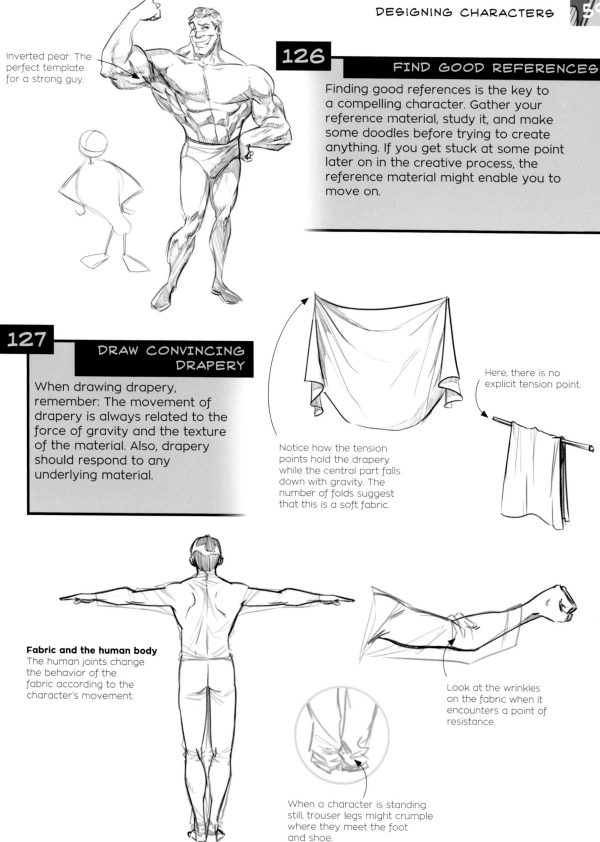

Inverted pear: The perfect template for a strong guy.

126 FIND GOOD REFERENCES

Finding good references is the key to a compelling character. Gather your reference material, study it, and make some doodles before trying to create anything. If you get stuck at some point later on in the creative process, the reference material might enable you to move on.

127 DRAW CONVINCING DRAPERY

When drawing drapery, remember: The movement of drapery is always related to the force of gravity and the texture of the material. Also, drapery should respond to any underlying material.

Notice how the tension points hold the drapery while the central part falls down with gravity. The number of folds suggest that this is a soft fabric.

Here, there is no explicit tension point.

Fabric and the human body
The human joints change the behavior of the fabric according to the character's movement.

Look at the wrinkles on the fabric when it encounters a point of resistance.

When a character is standing still, trouser legs might crumple where they meet the foot and shoe.

The cape is a good example of applying swooping movement (see page 22).

129
APPLY SWOOPING LINES

Motion adds a sense of dynamism to a drawing, which is especially important when drawing comic book heroes. Note the difference here: The first sketch has our hero standing in a stock pose. The second sketch, however, makes our hero look victorious, perhaps standing tall atop a skyscraper, overseeing his city—all thanks to the simple addition of a swooping line to send his cape billowing in the wind.

128
THINK ABOUT POSTURE

Even though your character may be standing on one spot, such as the figures here, you can give him a sense of life by adjusting his posture. Use the muscle groups (see pages 32–35) and think about the story and personality you are trying to convey.

Every part of this character looks strong, so give him a strong pose to match his physique.

Dynamic hands support the sense of floating.

Our hero is on a mission—clenched fists, streamlined body, and determined expression all combine to tell us this.

130 SUGGEST SPEED THROUGH POSTURE

Body posture radically changes the sense of motion and speed in our flying champion. An opened-palm, relaxed pose with a lightly billowing cape indicates he is floating effortlessly through the sky. In contrast, the tense posture in the example seen right tells us he needs to get somewhere in a hurry.

STYLIZATION

131 — UNDERSTAND "STYLE"

Many styles are associated with cultural issues and the artist's personal taste (and technical skills). Often, artists are exposed to a certain drawing style when they are already professionals and, from there, try to insert elements of this style into their own work. You can either adapt (or create) your own style, depending on the requirements of a particular project. Practice is the secret to achieving a distinctive style.

132 — EXPERIMENT WITH MODERN STYLES

Contemporary art styles embrace the graphic quality of the drawings with heavy emphasis on simple lines, shapes, and even colors as the main assets for designing characters. Movement can be depicted in simple, easily recognizable gestures, such as a waving hand.

Basic building blocks
You need only simple lines and shapes to give life and movement to a character.

133 — DRAW *NOIR* STYLE

Noir is more a narrative choice than a proper style. But more recently, especially with the rise of graphic novels, many artists have adopted the *noir* aesthetic as a basis for building their own style of storytelling. The use of contrasts between light and shadow highlight psychological aspects of the characters and heighten tension. Characters may move subtly and slowly, lurking or lingering in the shadows, or emerging into the light with intention.

Noir aesthetic
The *noir* style is perfect for tales of suspense and mystery.

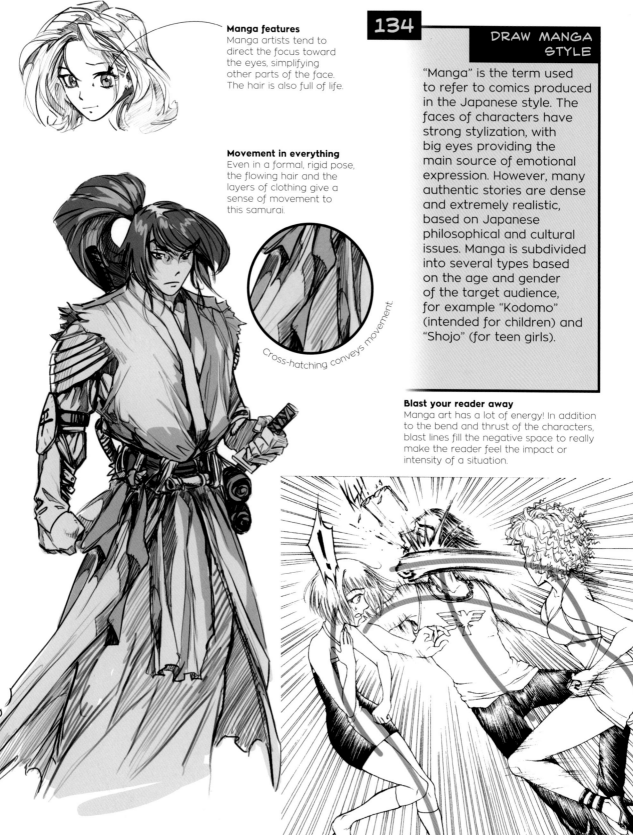

Manga features
Manga artists tend to direct the focus toward the eyes, simplifying other parts of the face. The hair is also full of life.

Movement in everything
Even in a formal, rigid pose, the flowing hair and the layers of clothing give a sense of movement to this samurai.

Cross-hatching conveys movement

134

DRAW MANGA STYLE

"Manga" is the term used to refer to comics produced in the Japanese style. The faces of characters have strong stylization, with big eyes providing the main source of emotional expression. However, many authentic stories are dense and extremely realistic, based on Japanese philosophical and cultural issues. Manga is subdivided into several types based on the age and gender of the target audience, for example "Kodomo" (intended for children) and "Shojo" (for teen girls).

Blast your reader away
Manga art has a lot of energy! In addition to the bend and thrust of the characters, blast lines fill the negative space to really make the reader feel the impact or intensity of a situation.

135 COMPARE REALISM VS. CARTOON

A realistic style demands that you use real life as your reference. You also lose some creative freedom, although a lot of excellent artists produce incredible results by drawing realistically, even in comics (look at the work of Norman Rockwell, for example). The fundamental basis of the cartoon style is the distortion of reality, helping the viewer identify more readily with the characters. It is important to learn the universal principles of character creation and play around with them, in order to master the style and to push things in different creative directions. This way you'll be able to distort reality based on your personal way of seeing life (see the work of Disney animator Milt Kahl).

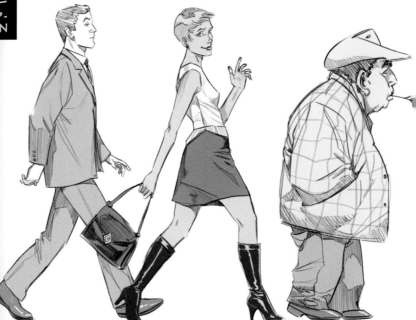

Realistic
These figures are walking with a believable motion of the extremities, as observed from real life.

Cartoon
Cartoons tend to be more exaggerated and free-flowing. Think of the figure as if it were made of soft, stretchable rubber. This creates more swooping curves and bendable limbs. The greater the bend or stretch, the more pronounced the movement becomes.

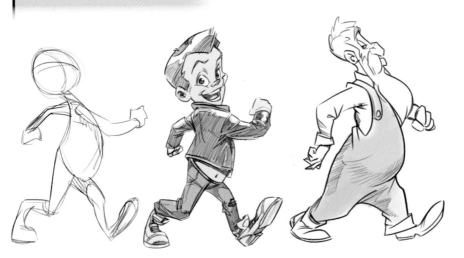

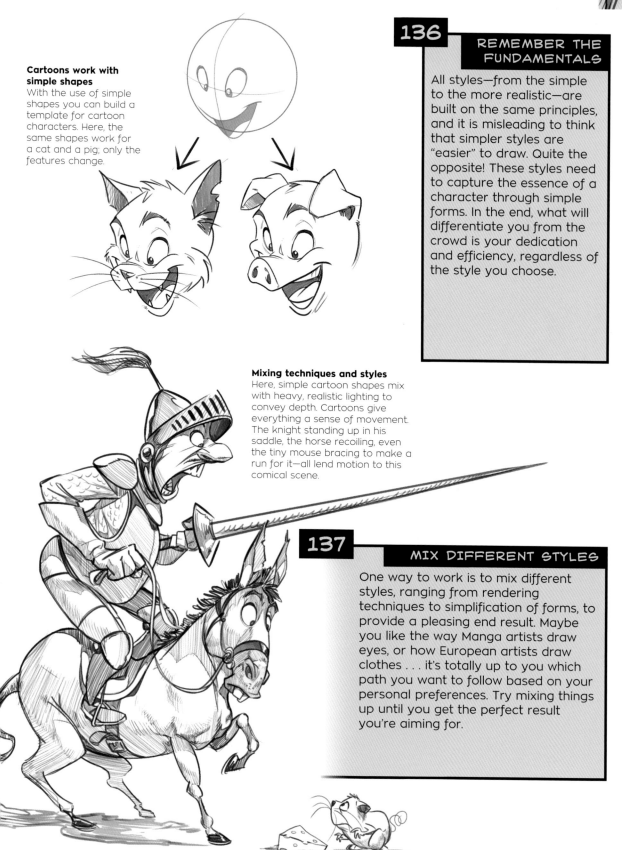

Cartoons work with simple shapes
With the use of simple shapes you can build a template for cartoon characters. Here, the same shapes work for a cat and a pig; only the features change.

136
REMEMBER THE FUNDAMENTALS

All styles—from the simple to the more realistic—are built on the same principles, and it is misleading to think that simpler styles are "easier" to draw. Quite the opposite! These styles need to capture the essence of a character through simple forms. In the end, what will differentiate you from the crowd is your dedication and efficiency, regardless of the style you choose.

Mixing techniques and styles
Here, simple cartoon shapes mix with heavy, realistic lighting to convey depth. Cartoons give everything a sense of movement. The knight standing up in his saddle, the horse recoiling, even the tiny mouse bracing to make a run for it—all lend motion to this comical scene.

137
MIX DIFFERENT STYLES

One way to work is to mix different styles, ranging from rendering techniques to simplification of forms, to provide a pleasing end result. Maybe you like the way Manga artists draw eyes, or how European artists draw clothes . . . it's totally up to you which path you want to follow based on your personal preferences. Try mixing things up until you get the perfect result you're aiming for.

HOW DIFFERENT CHARACTERS MOVE

Cartoon style exaggerates this character's roundness and the desperateness of his plight.

138 USE STYLE TO ENHANCE YOUR STORY

The differing styles of cartoon and realism need not always be exclusive. By combining one with the other, drawings can be enhanced. This comical fellow desperately running from the realistic-looking speeding car looks to be facing genuine danger, more so than he would fleeing from a bouncy, silly-looking vehicle. In this case, the opposing styles combine for a stronger image.

Fluid curves and swooshes convey dancing in unison.

139 IDENTIFY KEY POSTURES IN FAMILIAR ACTIVITIES

Dancing figures instantly bring to mind movement due to our familiarity with that activity. Here, the position of the spine combines with the outstretched arms, posture of the legs, and the female figure's swooping dress to convey that they have already begun their dance and are not merely striking poses waiting for the music to begin.

140
EXAGGERATE TO EMPHASIZE SPEED

The faster a figure moves, the more pronounced his gestures become. Arms pump in arcs and legs stretch farther. The trick is in knowing how far to take your gesture. The realistic man is running, but his cartoon counterpart is really pouring on the speed as his elastic limbs whirl around his frame with great exaggeration.

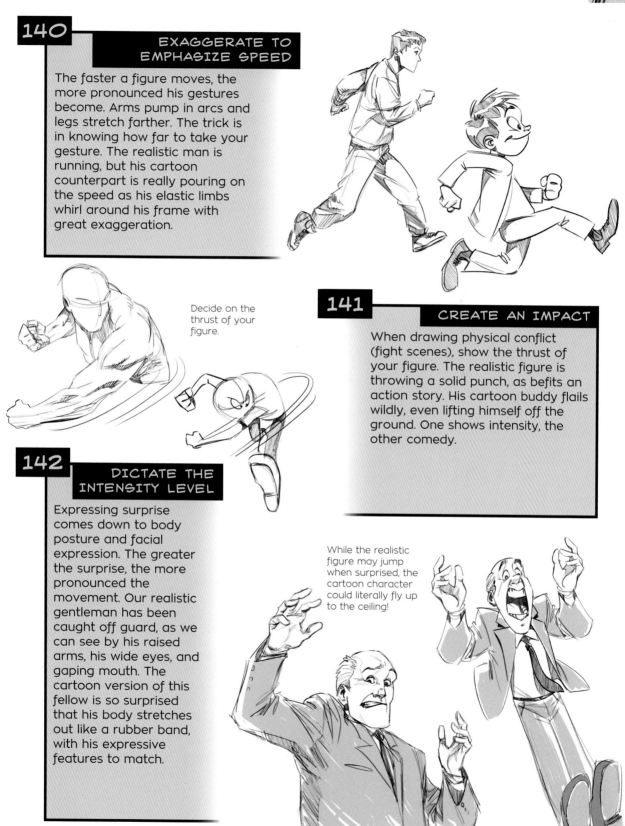

Decide on the thrust of your figure.

141
CREATE AN IMPACT

When drawing physical conflict (fight scenes), show the thrust of your figure. The realistic figure is throwing a solid punch, as befits an action story. His cartoon buddy flails wildly, even lifting himself off the ground. One shows intensity, the other comedy.

142
DICTATE THE INTENSITY LEVEL

Expressing surprise comes down to body posture and facial expression. The greater the surprise, the more pronounced the movement. Our realistic gentleman has been caught off guard, as we can see by his raised arms, his wide eyes, and gaping mouth. The cartoon version of this fellow is so surprised that his body stretches out like a rubber band, with his expressive features to match.

While the realistic figure may jump when surprised, the cartoon character could literally fly up to the ceiling!

BRITTANY MYERS

My name is Brittany Myers. I am currently a high school senior with a passion for animation and character design. I will be attending CalArts for character animation this Fall, as well as taking part in Walt Disney Animation's talent development program as a visual development artist.

QUESTIONS & ANSWERS

WHAT IS YOUR FAVORITE MEDIUM, AND WHY?
I prefer drawing digitally with my Cintiq tablet right into Photoshop.

NAME AN ILLUSTRATOR YOU ADMIRE:
Glen Keane. The level of expression and gesture in his work is inspiring.

WHAT INSPIRES YOU?
Everyday life and experiences inspire me in general. Many of the characters I draw are inspired by my own experiences, and sometimes by people I know.

DESCRIBE YOUR STYLE:
I would say my style is cartoon-y, with influences from many of today's modern animation styles.

Considering the personality is very important. What is the character thinking?

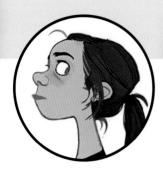

MY ART TIPS

143 One of the most important aspects of drawing, in my opinion, is storytelling. I try to use clear body language and expression in my character drawings. I think consideration of the personality is also very important. What is the character thinking? How are they feeling? And what are they doing?

144 Some other things I think are important to keep in mind are the concepts of straights vs. curves, tilts and turns, and silhouette. A lot more goes into drawing than just drawing pretty pictures. There are many little technical thoughts that run through my head as to what might make the drawing more appealing.

Keep in mind the concepts of straights vs. curves.

145 To improve your sense of movement and gesture in your drawings, I would strongly suggest gesture drawing. Whether by drawing from life or photos, putting a quick drawing onto paper really helps to develop your pose-drawing skills.

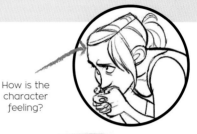

How is the character feeling?

Use clear body language and expression in character drawings.

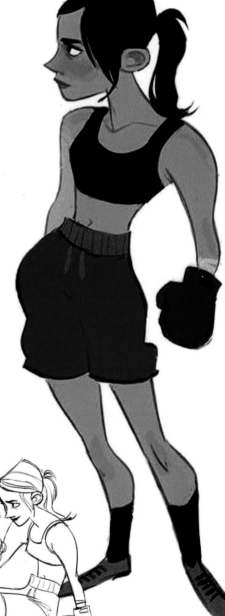

JONATHAN HILL

I live in Portland, Oregon. I graduated from the Savannah College of Art and Design in 2003, and have since been freelancing as a cartoonist. My work has appeared in publications by Fantagraphics, Dark Horse, and Image Comics. First Second Books published my first graphic novel, *Americus*. I teach comics at the Pacific Northwest College of Art.

QUESTIONS & ANSWERS

WHAT IS YOUR FAVORITE MEDIUM, AND WHY?
Brush and ink. I love the life and energy good brushwork has, and the act of inking is very meditative for me.

NAME AN ILLUSTRATOR YOU ADMIRE:
Meg Hunt (meghunt.com). She's been a friend of mine for years, and I'm constantly inspired by her dedication and her constant drive to push herself and her work.

WHAT INSPIRES YOU?
My students and other artist friends. Their passion and hard work is contagious. It makes me want to jump to my drafting table and make things!

DESCRIBE YOUR STYLE:
I think strong, expressive characters and clean linework define my style. I try to fill both my comics and illustrations with lots of fun details that keep the viewer coming back to try to catch everything.

Let your brushwork flow with energy.

The process of inking can be used to give your drawings clean lines.

MY ART TIPS

146 When inking, get away from the technical pen and try a brush or crowquill. Many beginning cartoonists cling to the technical pen (Micron, etc.) like a security blanket. I understand why—there's a small learning curve and it's easy to use. Not that I have anything against tech pens, but if you push yourself and try other inking tools, you'll find that with a little practice these other tools can give you a wider range of mark making, which translates into more expressive, energetic lines.

147 No matter what kind of illustration or cartooning you are doing, you will benefit greatly from drawing from observation. Draw on the bus, at coffee shops, or when watching sports games, television, etc. It will strengthen your drawing skills and give you a better understanding of anatomy and how the human body moves, which you can then apply to your drawings.

148 Draw straight with ink in your sketchbook. With pencils and the opportunity to erase, you can tend to get too precise with the drawings in your sketchbook. Drawing straight with ink lets you be looser and focus more on the act of drawing itself than the final product. Remember, your sketchbook should be a place for you to learn and experiment, not create finished pieces. The energy you cultivate in your sketchbook carries over when you are creating final pieces!

Draw from observation as much as you can, wherever you can.

Drawing with ink in your sketchbook helps to keep your sketches fluid—avoid perfectionism!

MORE PEARL ROOM CARICATURES

GOOGLE SEARCH 'PORTRAITS'

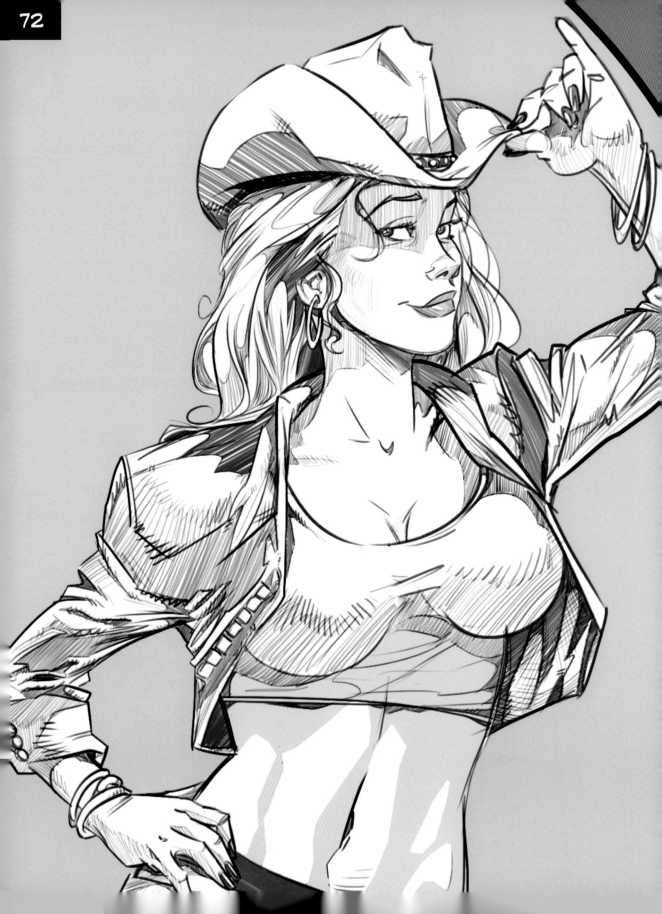

SECTION 3

MOVEMENT AND LIFE

FORESHORTENING

149

SEEK THE IMPACT

The goal when applying foreshortening is to make more of an impact, by tricking the viewer's eyes into believing that your figures or objects have real depth. By achieving this goal you will not only raise the technical level of your drawings, you'll also give them more life, by indicating movement in what might seem to be an otherwise static pose.

Perspectivized spheres
The closest ball to the camera is largest and overlaps the previous one, and so on. As they get farther away, they get smaller. Guidelines ensure the correct sizes.

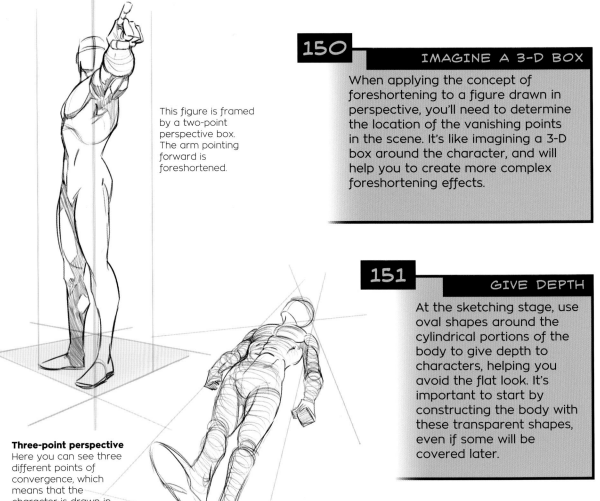

This figure is framed by a two-point perspective box. The arm pointing forward is foreshortened.

150

IMAGINE A 3-D BOX

When applying the concept of foreshortening to a figure drawn in perspective, you'll need to determine the location of the vanishing points in the scene. It's like imagining a 3-D box around the character, and will help you to create more complex foreshortening effects.

151

GIVE DEPTH

At the sketching stage, use oval shapes around the cylindrical portions of the body to give depth to characters, helping you avoid the flat look. It's important to start by constructing the body with these transparent shapes, even if some will be covered later.

Three-point perspective
Here you can see three different points of convergence, which means that the character is drawn in three-point perspective.

152

APPLY THE CENTER POINT PRINCIPLE

One challenge for beginner artists is turning a 2-D object into 3-D. First define the central axis of the object and then find the equivalent distances between the ends using geometrization. This technique works especially well with limbs (or any bending part), as it forces you to increase the size of things to correspond with the entire length of the original drawing.

Arm in perspective
When drawing the arm in perspective, the center point and the total distance of the arm in both drawings remains the same. The secret lies in overlapping the forms correctly.

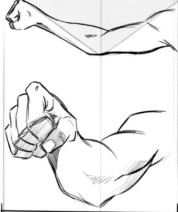

153

USE THE "Y" PRINCIPLE

A quick way to measure the foreshortening you use in your figures is to count the number of "Y"s in them. This is a simple way to map how much parts of your drawings overlap others.

Eye level of the viewer.

Play with foreshortening
Is our foreshortened character merely standing there with his hand up, or is he now in the process of reaching, stretching his limbs as we look at him? The drawing below right indicates the latter.

Just like limbs, clothes cause the "Y" effect when they are foreshortened.

Overlapping muscles
The "Y"s show where muscles overlap each other. You can apply foreshortening in one or more places in your drawing.

154

MAKE IT BIGGER

The character in the second image (left), apparently has one hand that is much bigger than in the picture where he is shown farther away. This is related to the relative distance from the camera. The closer to the camera, the greater the distortion and the more of a "fish-eye" effect you get—and the bigger the impact.

Eye level of the viewer.

155 INVOLVE YOUR AUDIENCE IN THE ACTION

Part of what makes a drawing dynamic is the use of dramatic shots, such as having a character look as if he is reaching out to grab you. The viewer can't help but be sucked into the action of our running hero.

Strength and intensity
The intensity and strength of the character is certainly captured in this pose. His body is designed in such a way that it is almost laid on top of the viewer. His facial expression is focused, his muscles are pumped, and his hand is reaching out for the viewer.

156 HIDE THE RIGHT THINGS

Creating truly impactful scenes means making choices. Make the wrong choices when you apply foreshortening, and you risk pushing your audience away, rather than attracting them. For instance, you don't want to hide the eyes of your character when his hand is in front of his face as he approaches the camera.

Considered omissions
Here the left calf and much of the left foot are omitted, as well as a small piece of the right leg; a small part of the head; and a small part of the left wrist. All of these were strategic choices, and this is a fine example of well-implemented foreshortening.

Eye level of the viewer.

157 MIX DIFFERENT ANGLES

One of the coolest things to do with characters when using foreshortening is to work different angles in the same drawing to create dynamically posed figures and bring huge impact to the action scenes. If the character is close to the camera you can also play with the relative sizes of elements, such as the leg here. Referring to the units on body language (pages 50–55), lighting (pages 24–27), and muscle structure (pages 32–37) will help here.

The angles, as well as the direction of the lines, are alternated for maximum dynamism and movement.

158 INVERT FORESHORTENING PERCEPTION

When thinking about foreshortening, the first thing that comes to mind is to throw objects or body parts toward the camera for impact. But you can also apply the inverse concept, which is to dramatically move the main objects away from the camera.

Creative foreshortening
Here a black-gloved arm in the foreground reaches to grab the standing character, but instead of having the hand approaching the camera, it is moving away from it. Try to explore more creative ways to use foreshortening to avoid repetition.

FLEXIBILITY AND EXAGGERATION

159

ENHANCE THE ACTING

Dynamic art bends real-world rules to bring life to fictional characters. Regardless of style, the "acting" needs to be a bit stronger than in real life. The viewer must never be in doubt about what is happening in the scene. Think about how far you can stretch your character, using momentum to force the stretch.

Spot the difference
This first image shows how an athlete runs in real life, even at full speed.

160

DON'T TRACE REAL PICTURES

Never trace real images in dynamic art; photos or magazine pictures should be used only as a reference. Dynamic art requires the use of resources such as the line of action (see page 92) to produce the most interesting results.

This drawing shows how you should portray the exaggerated athlete: Defined muscles, great pose with foreshortening, and flexibility (his feet are not touching the ground).

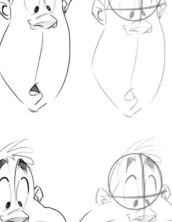

Some parts don't change
Once you have defined the flexible tissue of your character, maintain consistency so you don't have a rubber human. Notice in the drawings at the left that the skull remains unchanged; only the chin stretches and shrinks. Inspired by real life!

161

SQUASH AND STRETCH

A trick widely used to convey dynamism and movement in characters is one of the most famous principles of animation: squash and stretch. As the name suggests, the trick is to stretch and squash the character or object to create visual interest.

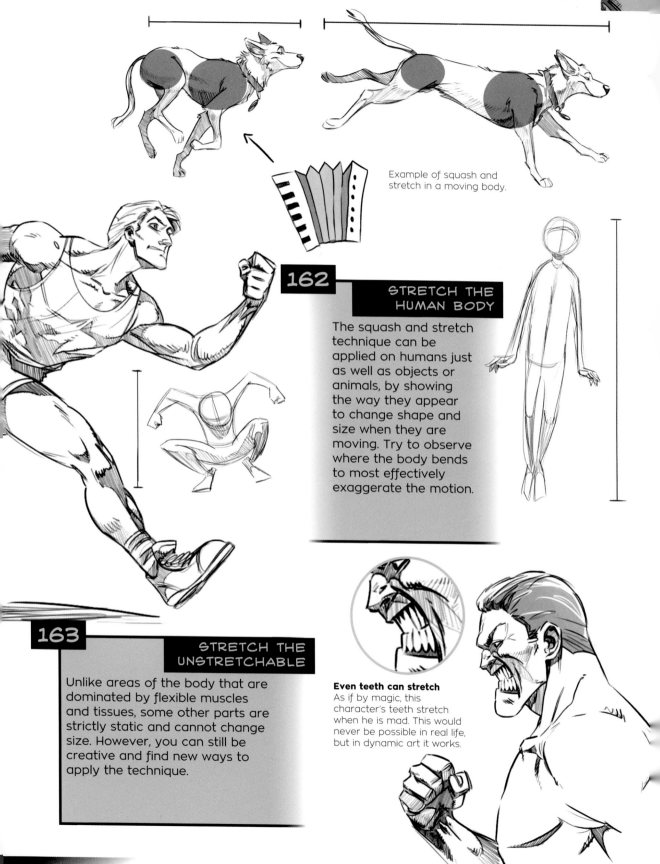

Example of squash and stretch in a moving body.

162
STRETCH THE HUMAN BODY

The squash and stretch technique can be applied on humans just as well as objects or animals, by showing the way they appear to change shape and size when they are moving. Try to observe where the body bends to most effectively exaggerate the motion.

163
STRETCH THE UNSTRETCHABLE

Unlike areas of the body that are dominated by flexible muscles and tissues, some other parts are strictly static and cannot change size. However, you can still be creative and find new ways to apply the technique.

Even teeth can stretch
As if by magic, this character's teeth stretch when he is mad. This would never be possible in real life, but in dynamic art it works.

164 STRIKE A MODEL POSE

Heroic and fearless characters behave differently from ordinary human beings. They can even pose like catalog models. Although you will rarely see these poses in real life, they can have great visual appeal and can be necessary to exaggerate certain parts of the body.

165 SHOW MUSCLES

Notice how the muscles in the arms of the man shown here are too big—many of them are bigger than his head. You're never going see this in real life. However, this is still a plausible figure. This is because, even with all the exaggeration, the proportions are based on real anatomy and the actual structure of the human body.

Notice how both figures have longer legs than normal people. Their trunks are squashed to compensate for the stretched legs.

166 BREAK THE JOINTS

"Breaking the joints" means bending parts of the body that follow a natural flow of movement. These joints include elbows, wrists, hips, knees, and so on. Try to explore points of bending that offer a good range of movement, such as the wrist.

Explore the potential for flexibility in the arms and wrists for more movement.

Inject some dynamism
Despite having nothing wrong with it, the first hand is not as dynamic as the second. The fingers of the second hand are not linear like those in the first image.

167
PAY ATTENTION TO ANATOMICAL LIMITATIONS

While you can exaggerate your characters by overcoming their physical limits to create visual interest, you must be careful not to create something that doesn't make any sense. You need a firm grasp of the rules of figure drawing to allow you to overstate with credibility.

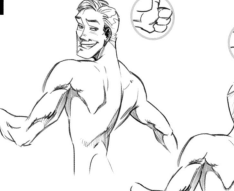

Unreal move
The second pose is only possible in horror movies!

The eyes appear to jump off the face—this is an exaggerated representation of a natural reaction.

Think context
Here exaggerations have been applied according to the character's context. His body is overly inclined toward the object of interest. The waistline is well above the normal line, and the full measure of his head is almost the same as his trunk.

168
APPLY SOME CARTOON CRAZINESS

A little craziness and escape from the rules of reality is good—showing the extreme changes in the physical appearance of a character, or in elements of the scene in which they are involved. However, it's important to choose carefully where to exaggerate (and where not to) so that the scene can still be believable.

169
GET TEX AVERY HUMOR

Tex Avery was an animator who insisted on pushing situations to limits possible only in animation, which was revolutionary at the time—eyes that leap off the face, chins that tumble to the ground, and characters who stand in the air for seconds before falling. Try to incorporate this kind of humor into your drawings to inject more movement and visual interest.

WEIGHT

170 GIVE IN TO GRAVITY

Gravity is responsible for giving weight to objects when they are released in the air; the Earth's attractive force (gravitational pull) causes them to fall to the ground. A basic understanding of this theory is essential so you can give weight to your characters, making them more credible.

Arrangement of shapes
This character is a set of rounded shapes being pulled down to the ground.

Observe water
A single drop of water shows how gravity acts on a substance. Notice how the bottom part retains all the weight.

171 CONVEY MATERIAL BEHAVIOR

Interactions between different forms and materials each need to be handled in a specific way. Understanding how different objects and materials behave when they move and meet is essential for any artist.

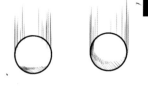

Soft objects such as this ball change when they hit something solid. Likewise, most solid objects will change a soft surface that they strike.

Glass
When glass hits a hard surface, it shatters, and pieces go everywhere.

172 LET SHAPES BE MUTABLE

Objects change shape depending on the surface underneath them. Take, for example, a bouncing ball: When a soft falling ball hits a solid surface, it will squash a little on impact, then return to its original shape.

A solid ball bounces without changing its form.

Yielding to pressure
If you press down hard on a solid surface with your fingertips, your fingers will bend.

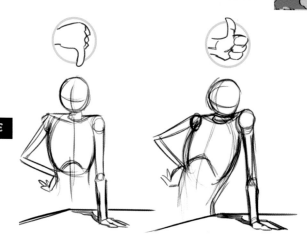

173 APPLY PRESSURE

An effective way to represent the weight of objects in drawings is through the use of pressure. Pressing down on any hard, solid surface will affect some kind of change, which might be in the object or elsewhere in the body if the object will not be moved. When something will not be moved from its original state, this is known as resistance.

The effect of leaning
If we lean on something and use our hand to support us, we take the weight through our arm and the shoulder alignment changes. If the support is then removed without warning, we fall.

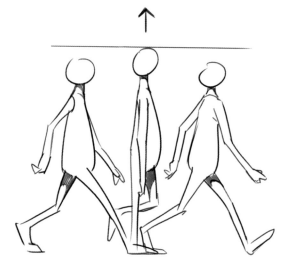

174 UNDERSTAND FORWARD MOVEMENT

There is no simpler way to convey weight than by showing the act of walking or running. When we walk, we are trying not only to move forward but also to keep from falling on the floor.

Walking blueprint
The arms are always in opposition to the legs. When one leg is straight, our body rises a little—crossing with the arm in the straight position.

Running blueprint
When we run, our trunk is projected forward. If we lose the balance on the front leg, we will suffer a very violent fall, in proportion to our speed.

175 VARY WALKS

Not all people have the same kind of walk. They carry their weight in different ways based on two factors: Emotional and physical. Is your character young or elderly? Intimidating or shy? Happy, sad, worried, or depressed? Think about the message you want to convey.

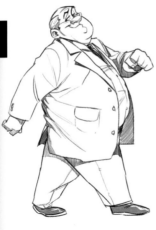

A person may walk with pride, if he is emotionally secure and socially confident.

However, age and low self-esteem can affect the way a person carries himself.

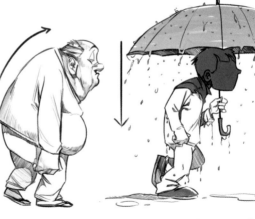

Intense adverse weather conditions such as rain or wind can affect the way a person moves.

176 KNOW WHAT INFLUENCES SPEED

Objects reach different speeds when released into the air, depending on their shape. For instance, while a ball falls straight down, the same will not occur with a handful of leaves. They will trap air beneath them and float down from side to side until they hit the ground.

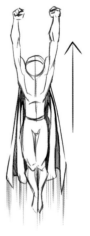

Showing the weight
The clever use of shading on the front foot implies a shifting of weight here, giving an impression of a spring in the step.

Use details to tell a story
See how the clothes inflate slightly as the person inside them falls. The more information you offer the viewer about the density and resistance of objects, the more engaging your art will be.

Inverse concept
When the body flies up, the cape does not inflate. It remains straight.

177 KEEP ON GOING...

Anything that moves—regardless of its density—tends to keep moving in some way even after a complete stop. The extent of this effect depends on the object's weight. Think of a locomotive stopping, for example.

Follow-through
A woman in a long dress can stop instantly with ease, but her dress tends to stay in motion a fraction longer. In animation, this technique is called "follow-through," and is used to give more realism.

178 KNOW WHERE TO APPLY THE WEIGHT

People carry their weight in characteristic areas of the body, which affects their movement. For instance, a strong man has a higher concentration of weight around the rib cage, while an elderly person may have a major concentration of weight on the back.

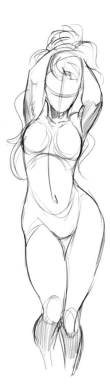

Bottom-heavy
Some women may have a higher mass in the pelvic area.

Top-heavy
Babies have very large heads and small limbs, which causes them to overbalance often.

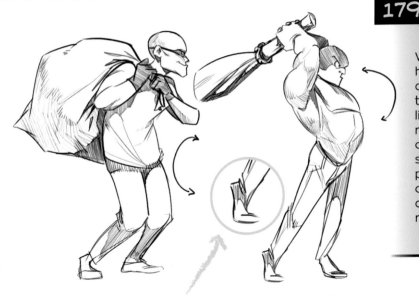

179

NOTE THE ARCH OF THE BACK

When a person lifts a weight over his/her shoulder, the spine makes a "C" shape to counterbalance the weight behind. With a weight lifted over the head, the "C" is reversed. The spine is a vital component of our strength—showing the correct spine position is the secret to convincing the viewer that a character is carrying a real weight.

This character is on his tiptoes to add impact to his pose; the entire body helps support the weight.

180

SHOW PREPARATION

A practical way to show weight is to communicate the prior effort involved in moving something from its natural state. This could be to change the direction of an object, or simply to pick up our body off the floor. These necessary acts are known as "preparation acts" or "anticipation"—concepts widely studied in animation. Think, for example, about how many bounces a trampolinist makes before performing the perfect jump.

Raised elbows
Elbows might be raised in preparation for a jump, or to lift a heavy weight. Both are "preparation acts," but with different purposes.

Feminine pose
The angles of the shoulders and hips emphasize the femininity of the figure, adding a special charm.

181

SET UP OPPOSITION

However we move, and whatever our size, when we're standing in line, walking, running, swimming, or even writing, we are constantly shifting our weight from one side to the other. A technique used to convey this is to draw the shoulders opposed to the hips, so when the right shoulder is tilted down, draw the right hip tilted up, and vice versa.

Draw guidelines to help you perfect this technique.

DYNAMIC HANDS

182 KNOW THE BASIC STRUCTURE

Hands are one of the most expressive parts of the body. They can broadcast upcoming motion as much as they can express flowing movement in action. To use the hands to their full potential to show movement, it is necessary to understand their structure. In the diagram at right, I've shown the main components of the hands, front and back, so that you can get an idea of their shape and the major muscle groups.

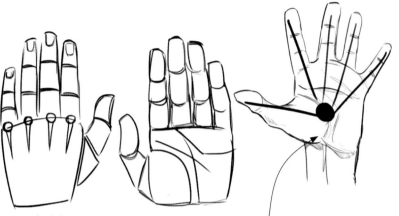

Simplified shape.

Note that there is a central point from which all fingers radiate.

183 FIND THE TRIANGLES

Once you understand the basic shape of the hand, you can identify how to position it. Notice how the major muscle groups can be translated into simple triangles. Don't forget that these shapes can change depending on the position and angle of view—you are dealing with flexible tissues.

Notice how the major muscle groups are shaded.

184 EMPHASIZE CURVES

When drawing hands in any style you must emphasize their curvy forms. They are a complex part of the human body, and tend to be a weak point for many artists. Note the curvature of the fingers, and how they differ from each other in size and in shape.

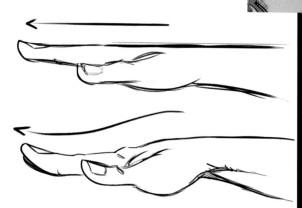

The hand in profile
Notice how the hand in profile does not lie in a straight line. Even when stretched out, it has a slight curve. See how the second drawing here appears much more dynamic than the first.

185 CAPTURE THE ESSENCE

At the draft stage, before you finalize your character's hands, try to think of how they can be used to support the overall composition. Capture the essence of the movement first. Once you've decided the general outline and the hands' main role in the body language, completion will be much easier and more natural.

Both the position of the fingers and the flow of the wrist, as it connects to the fingers, provide a sense of movement.

186 FOLLOW THE NATURAL FLOW

Follow the flow of movement in the muscles that run through the wrist and fingers to pose your character's hands dynamically. The positioning of hands will always mean something, but it need not mean the same thing every time. With careful attention paid to the figure's natural movement, you can use hands to support the body's overall pose and avoid bland stock poses.

The fluid gesture of a hand coming to rest on a flat surface can be applied to a villain bragging, "As you can see by this map, my plan cannot fail!" Yet it could also apply to the hero rising from his chair to reply, "We'll just see about that!"

The tight fist is quickly recognized as a symbol of conflict. This fist could be hurtling toward an opponent, or have just landed a blow with devastating impact.

Notice how the final design of the fist is based on a simple box.

187 EXPLOIT THE LITTLE FINGER

Have you ever noticed that the little finger has the biggest range of gestures? In general, as you move away from the index finger, the other fingers become less static. Highlighting the movement of the little finger in your drawings can make your art much more dynamic.

Draw the viewer in
Movement becomes much more interesting when you involve the little finger—enhancing the gesture and bringing it to life.

188 WATCH INVOLUNTARY GESTURES

Hands are a great communication vehicle, able to reaffirm or deepen the emotion or gesture you want to convey. But just as they can be used to reinforce a message, they can also give away a liar, because they assume positions involuntarily. Learn to use them to enhance body language.

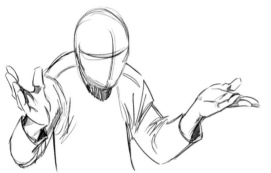

189 IDENTIFY UNIVERSAL GESTURES

There are some gestures that are universally recognized—a kind of informal sign language—and it is important to be aware of these. Try to identify all of them in order to incorporate them into your artwork.

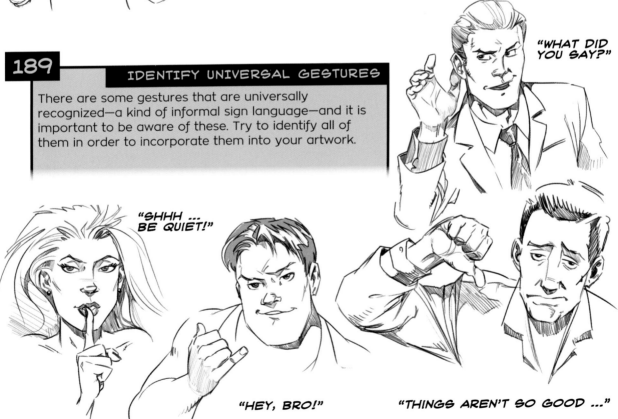

"WHAT DID YOU SAY?"

"SHHH ... BE QUIET!"

"HEY, BRO!"

"THINGS AREN'T SO GOOD ..."

190 TALK WITH THE HANDS

As well as complementing facial and body expressions, the hands can also express feelings on their own. This technique comes in handy if you need a close-up panel in a strip or storyboard.

"I'M SO ANGRY!!"

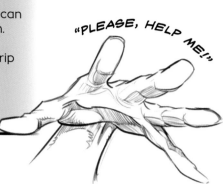

"PLEASE, HELP ME!"

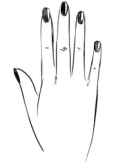

Older hands
Older people have more wrinkled hands and knuckles (due to the thin skin) and are usually represented with larger nails.

Female hands
Female hands are represented with more graceful and slender forms, with larger nails and more rounded fingertips.

191 OBSERVE DIFFERENCES

Characters should have hands that are consistent with their gender, age, and personality. For example, male hands are thicker, stronger, and have a more weathered look than female hands; they are generally squarer at the finger tips. Children are at the other extreme and have much more rounded hands that are generally chubby.

192 DON'T OVERDO THE FINGERS

If you try to draw each finger with its own gesture and position, the hand will look odd. Fingers work collaboratively and often follow the movement of their closest neighbors. You can push this point much farther in a cartoon than in a more realistic drawing, but be careful not to overdo it and lose a sense of accuracy.

193 USE HANDS TO SUPPORT GESTURE

Hands are very important in gestural drawing. To deny this potential is one of the biggest mistakes that an artist can make; it's like denying the second most important body communication tool after the face. Make sure you use them to their full potential.

POWERFUL ACTION

Notice how the movements were built based on the line of action: It's the line that connects and leads all the auxiliary movements of the body.

194 LEAD THE ACTION

The line of action is an imaginary line responsible for leading the action of your character. Its main use is to enhance the dramatic effect of a certain movement. It should be fluid and streamlined and show the real intentions of a movement.

195 USE PARALLEL LINES FOR MOVEMENT

Parallel speed lines are extremely effective and are widely used to show movement, regardless of drawing style. Always draw them in the opposite direction to the main movement, and keep them straight. (Use a ruler if you need to.)

Parallel lines can be used for human figures—particularly in the flight scenes of a superhero, for instance, or to represent any other type of action scene that demands agility.

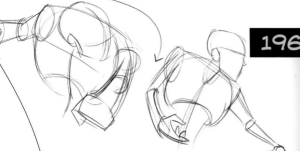

While one arm hits the victim, the other one retracts. This keeps the body of the aggressor balanced, while the victim feels the opposite effect.

196 | DRAW OVERLAPPING ACTIONS

When any action like a punch occurs, you can use several techniques to demonstrate its intensity. One of these is overlapping actions, which simply means that your character adheres to the laws of physics. "Follow-through action" and "overlapping action" are among Disney's Twelve Basic Principles of Animation.

197 | CONSIDER RESULTING ACTIONS

Here, the guy who strikes has his eyes open (all the better to hit his target), while the victim has his eyes closed. When you get punched in the face, you close your eyes, right? Think about cause and effect.

Taking the blow
The character receives a blow to the face; his arms are moving from the impact, as well as his hair and tie. This is the essence of overlapping action.

Reading the scene
The character who strikes has his body hanging forward, as if the arm is carrying all his weight. His clothes move as a result of the action, helping us read the scene.

198 | EMPHASIZE RESULTING ACTIONS

Sometimes it is better to emphasize the result of an action rather than the act itself. Take the punch as an example. What is more interesting to show—the exact time the punch reaches the face of the character, or the damage it causes? Obviously—in this case—the answer is the second option.

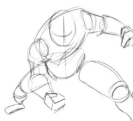

Strike a pose
Modify the position of the arms and legs until you find the best dynamic pose.

199 SPREAD THE LEGS

As action poses require sudden movements, a shift in body weight is natural to maintain balance (see "Weight," pages 82–87). A simple way to ensure a dynamic pose is to keep your characters' legs spread apart. This is also an effective way of showing that your character is ready for battle.

200 MAKE SHOULDERS DYNAMIC

As a rule, the more asymmetric the pose, the more dynamic the scene. Therefore, whenever possible, avoid aligning the shoulders of your characters. Just remember to be consistent with the lines of action.

Pay attention to the line of action. Note the "S" curve in the center of the body.

201 SWIVEL THE HIPS

"Hips don't lie," Shakira once sang—and she was right: Turning the hips of a character performing an action creates impact. The hips are the best way to explore dynamism in your characters. Incorporate some foreshortening into the scene, and you're done: Hip power rules!

Turned hips
The chest of the character slightly turns to the side while his legs are facing the viewer. The feet are hidden to strengthen the composition.

202
USE TEMPLATES

It can be a hard task to make several action poses within a scene consistently good. However, there are established movements that you can reuse to great effect. Over time you will find what works for you (and what doesn't). This will help you to develop a distinct style.

The position of the legs is the same each time—certain movements work well in this way and can be used repeatedly.

203
BREAK THE RULES

The "rules" for drawing characters in action should not limit your artistic decisions. Some rules must be broken to give your figures more style and personality. Often your particular way of doing things will be what sets your characters apart. It's your duty to exceed your audience's expectations.

204
NEVER THINK THAT YOUR FIRST ATTEMPT IS THE BEST

Action scenes command attention. For this reason it's necessary to take risks and seek the best angle in every single one. Work with lines of action, thumbnails, and soft sketches to create different versions of the same movement, until you find the perfect expression. Don't be lazy!

ANIMAL MOVEMENT, BY DONNA LEE

205

FEEL THE GESTURES

Before drawing anything, it's important to understand your subject and think about the character you would like to capture. As many animators have done, envision yourself as the subject and really feel out the poses, even if the subject isn't human. Feel the gesture as you're drawing and think about what your subject is thinking or doing as you work. Keep your hand loose so that the gesture flows out naturally.

206

LINE OF ACTION: ROUGH IT OUT

Simplifying the gesture to a line of action will help you to focus and communicate it clearly. The line of action should lead the eye through the drawing and convey the direction of movement.

Here, the line of action follows the little dog's spine. The line indicates the direction of the action the figure will take.

Everything else on the dog reflects the main motion, whether he is walking, crouching, scratching his ear, or rolling over at the end of a long day's play.

207 — BRING IT TO LIFE

Once a rough drawing is made, consider what could make your drawing more unique and believeable. For instance, the way the stomach pulls on the dog's back, the weight and tension in the legs, and how the head droops can all add to your drawing, and bring it more to life.

The heavy black on the legs and tail lead the eye downward. A straight back, with its black saddle, leads the eye directly to the dog's head.

The dog's snout, as well as the focus of his eyes, bring the reader to the spot that has captured the dog's attention.

Through its active pose, the drawing creates a sense of movement and leads the eye of the reader.

These color blocks show how some parts of your drawing can indicate movement without moving much themselves. The perked-up ears, raised tail, and curved back show us a happy dog, ready to play.

208 — FINISHING TOUCHES

After mapping out the gesture, you can go back to the drawing and make adjustments to finesse the design.

ELISA FERRARI

Hi! My name is Elisa Ferrari and I am an Italian comic artist based in Verona. I have always loved drawing, and after graduating I decided to try to become a professional comic artist. A few years ago I started collaborating with various artists on my first works. Now, I am working as a freelance illustrator and comic artist, mainly for the Italian publishing industry.

QUESTIONS & ANSWERS

WHAT IS YOUR FAVORITE MEDIUM, AND WHY?
I mainly work in digital, with my beloved Cintiq and Manga Studio. They give me the freedom and the self-confidence I need to do my best work. One day I would like to learn to use watercolors and traditional inking instruments, like the brush and nib.

NAME AN ILLUSTRATOR YOU ADMIRE:
I love the work of so many artists that it is really hard to choose. But if I have to, I will say Enrique Fernandez. He is a Spanish comic artist and I consider his style a perfect fusion between his strong and personal use of color and his extraordinary way of inking. Each panel is a real journey for your eyes. Check out his amazing work, if you don't know him yet.

WHAT INSPIRES YOU?
I am inspired by all that is deeply true and real, which does not mean that I like the realistic kind of literature or art. I simply mean that, in every genre, even in fantasy, I look for those stories and characters that have something deeply authentic to tell me, and are not stereotyped.

DESCRIBE YOUR STYLE:
My style is a combination of Disney and manga—a kind of "Euro-manga."

Observe yourself! Practice reactions and gestures in front of a mirror or webcam.

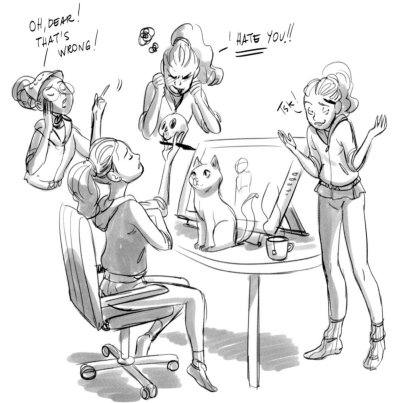

Give a sense of movement to all your characters by involving every part of the body in the communication.

Static characters are less engaging.

MY ART TIPS

209 One of the things I always do to better understand movement is carefully observe people around me. I do not usually draw them in a sketchbook—I just try to memorize their actions and make them my own. You know, each one of us has our own repertoire of gestures, and I think that to observe ways of being different from our own can provide great inspiration in the kind of work we do. So when we draw, it becomes an infinite database of dynamic inspiration, and it makes our stories richer.

210 If you could come into my room while I'm working on a comic, you would see me acting by myself in front of my Cintiq; I try to remind myself what I have seen in real life or what I would do in a particular situation. This is also an exercise to help me get out from my usual way of drawing and make a scene more interesting and dynamic—even something as simple as three characters talking to each other.

211 Change every time! Is your character doing the same thing in three different moments? Are some other guys doing the same thing at the same moment in the next panel? Always try to make each scene interesting, and not repetitive. Remember to use every part of your character's body to communicate more clearly. We don't only use our mouths and our eyes to speak.

BORED EMPLOYEE

RESIGNED MOM

ANXIOUS YOUNG GIRL

IMPATIENT BUSINESSMAN

POST OFFICE

ME, CURIOUS

Consider the mood of your character and match it to the appropriate posture. Everyone is different, even in the same situation.

LOUIS DECREVEL

I love writing and drawing! I live on a small farm in the Inman Valley, Australia, with my amazing wife and our small horde of hilarious children. I have a BA in Multimedia and a Master of Visual Art & Design (Illustration), both from the University of South Australia.

QUESTIONS & ANSWERS

WHAT IS YOUR FAVORITE MEDIUM AND WHY?
I use pencil for sketching and digital for work, because speed is crucial. Ink and watercolor otherwise, because of Calvin and Hobbes. That's a reason, right?

NAME AN ILLUSTRATOR YOU ADMIRE:
Just one? Okay, then: Howard Pyle, Quentin Blake, Sergio Aragonés, Bill Watterson, Jeff Smith, and Ben Hatke, all mushed up together. Gross, but amazing.

WHAT INSPIRES YOU?
Iced coffee, adventure stories, the local countryside, and the wild children bouncing outside my studio window.

DESCRIBE YOUR STYLE:
Energetic, expressive, friendly, and fun.

MY ART TIPS

212 Sketch fast—your pencil should be a blur. The aim is to stop your brain from second-guessing everything. If you can work fast and small, you can bang out half-a-dozen thumbnails in a minute or two. If you have movement and vitality in your initial sketches, it will translate into your finished art.

213 Sequential action—you can bring the power of comics into illustration if you have multiple characters performing the same action, each at a progressive stage. In the case of firing a gun, the first character could be loading, the second aiming, and the third firing. This enables the viewer to read the movement visually.

214 Freeze-frame—think of your illustration as a paused movie screen. You want to press pause at the peak of the action, to reference both what has come before and what is about to happen. The environment is also paused mid-movement: static dust, hovering beads of sweat, birds stuck in midair, superheroes frozen in flight. Your goal is to make the viewer want to press play.

Start with movement in your preliminary sketches and end with an explosive mid-action scene.

Treat movement as a progressive action: know what stage your character is depicting.

SECTION 4

STORYTELLING

DIRECT YOUR CHARACTERS

215

BE OBJECTIVE WHEN NECESSARY

Clarity is important when telling a story, and there's no better way to drive characters than by presenting them objectively— that is, as if we were in a theater, watching them acting. This technique is called "objective plane."

Directing the eye
Sometimes, the most important movement is that of the reader's eye across the scene or page. Integral elements such as light, foreshortening, and body language move the eye from one position to the next, taking it where we want it to go.

216

TURN THE VIEWER INTO A CHARACTER

The "subjective plane" is a framing technique in which the viewer acts like the eyes of one of the characters (think of first-person computer games). See how the characters stare directly at the viewer: This effect is extremely powerful and, in most cases, is associated with one-point perspective.

First-person viewpoint
This is one-point perspective: If you follow the lines of the table, you can find the vanishing point behind the character at the center.

217

USE THE DOWNSHOT TO CONVEY LACK OF POWER

There are plenty of ways you can apply a downshot—also called "bird's-eye view"—in a scene. There is an automatic superiority effect, causing the character to "shrink" and seem fragile. This notion may help you to make use of the ideal camera angle to convey the necessary information to your viewer.

218

USE THE UPSHOT TO CONVEY THREAT

When you want to make a character or object seem intimidating, you can use the upshot technique (also called "worm's-eye view"). This is, arguably, the most uncomfortable angle that exists; we're not used to seeing people and objects in this way, which causes discomfort to the viewer and creates immediate visual interest.

219

PLAY WITH LIGHTING IN UPSHOT ANGLES

The correct use of light and shade adds spice to the upshot. When we light a character—or object—in this way, from beneath, we instantly create visual interest because we are used to light coming from above (ceiling lights, sunlight, etc.). Here the shadows enhance the character and add volume to his face. Think about horror movies and how threatening characters are lit to understand this principle.

Throw light on strong features
Here the light favors the strongest features, such as the prominent chin, the sarcastic smile, and the penetrating gaze.

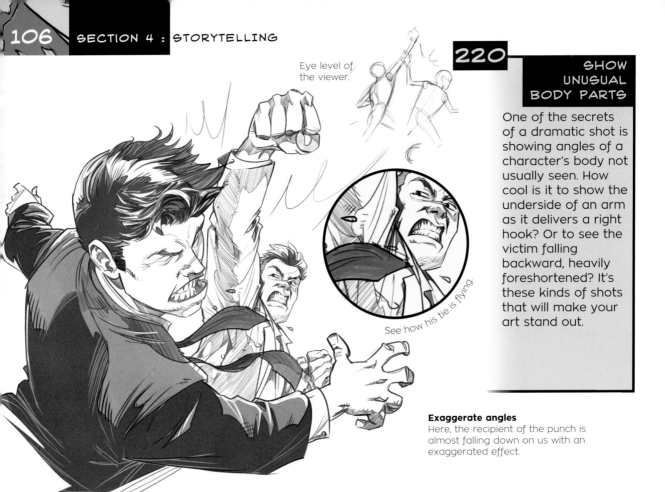

Eye level of the viewer.

See how his tie is flying.

220 SHOW UNUSUAL BODY PARTS

One of the secrets of a dramatic shot is showing angles of a character's body not usually seen. How cool is it to show the underside of an arm as it delivers a right hook? Or to see the victim falling backward, heavily foreshortened? It's these kinds of shots that will make your art stand out.

Exaggerate angles
Here, the recipient of the punch is almost falling down on us with an exaggerated effect.

221 CREATE SOME MYSTERY AROUND THE CHARACTER

When telling a story, you need to make the viewer feel as if they are in the scene. A character must be introduced in a manner consistent with his/her role, his/her personality, and his/her attitude. One way to do this is to involve the character in the scene in a mysterious context, where all is not yet clear to the viewer. This is a VERY exciting technique!

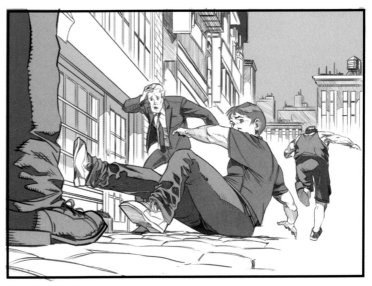

Mysterious entrance
In this scene, we see people running away from someone, but we don't know who! All we can see is his foot: Who is he? A hero? A villain? What's he doing there? Is he carrying a lethal virus? Here, the upshot angle also lends dramatic impact to the scene.

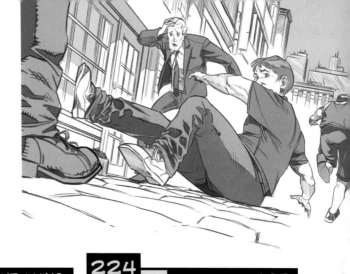

DESTABILIZE THE VIEWER

Your character may feel disorientated by the strangeness of the moment in extreme-action situations. To simulate moments like this, you can use "Dutch angle," where the sloping horizon line is used to evoke a sense of imbalance and displacement.

223

EXPLORE DIFFERENT WAYS TO TELL A STORY

Sometimes, as in the movies, we are allowed to see the world through the eyes of our characters. An interesting way to do this is by using reflections: In a glass bottle, a river, or, as in this example, a simple mirror.

224

USE SILHOUETTES

If you believe in the material you produce and are sure that everything will be clear enough for the viewer, it can be interesting to use silhouettes. The contrast between values creates a strong design feature and can even bring more life to the art (as strange as that may seem). Don't worry about the lack of detail; the viewer's brain will complete the picture.

Reflection in a mirror.

Outlines add interest
Additional lines mark the clothes, eyes, and some parts of the tree.

COMPOSITION RULES

225 USE THE RULE OF THIRDS

Often something just doesn't look right in a drawing. The rule of thirds is a helpful technique that can give compositions a more natural and yet precise look. Simply draw a grid that is split into three parts vertically and horizontally. Use these guidelines to help you place elements in a composition for a more harmonious and balanced result.

No clear subject
Here, there isn't a clear subject—only a horizon and a sky with clouds. Simply align the horizon with the lower horizontal line of your grid to achieve a pleasing composition.

Obvious subject
The clear subject is the isolated tree on the horizon. Align the tree with one of the vertical gridlines, while keeping the ground (horizon) aligned with the lower horizontal line for a naturally pleasing look.

Opening up the shot
The foreground items in this scene are positioned in the corner, freeing up the center.

226 INVITE THE VIEWER IN

There are times when the rule of thirds is not applicable: Either due to the frame size, or simply because the context does not suggest it. Remember—it is just a tool. However, try to avoid centering the composition. By placing objects toward the edges of the image you invite the viewer into the scene.

227

THINK ABOUT ALIGNMENT

When a person is talking to or looking directly at the camera (see page 104), they may be aligned in the center of the frame. But if the character is in dialog with someone else or directing their gaze to another point, it looks more natural to align them toward the right or left of the frame, depending on the context.

228

PROVIDE SPACE

When aligning a character in a composition, always leave head space above them—especially in fairly open scenes like the one shown right. Also, allowing space in front of the character looks much more natural and inviting.

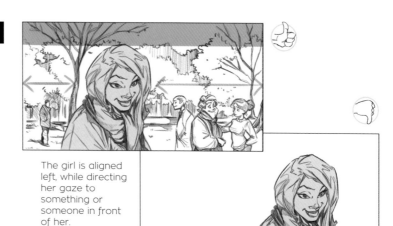

The girl is aligned left, while directing her gaze to something or someone in front of her.

If she were positioned on the right, there would appear to be very little "breathing space" between the frame border and the character.

229

DON'T CUT THROUGH JOINTS

When drawing characters in a frame, many artists disregard the bottom part of the body, showing only from the head to halfway down the leg. However, if you do this, don't cut through the joints, or it will look as if your character is missing body parts.

Placing the cut
When cutting off a character at leg height, find a space between the knees and the ankles (in this case, the lower shin).

230 ACHIEVE CONTINUITY

No matter how our figures move, they cannot exist in empty space. Let's look at background composition and how our figure relates to it. If you're creating a storyboard in which characters go from point A to point B, make sure you don't break the 180-degree rule. Imagine a line that blocks the camera's passage from one side of the image to the other. Never cross to the other side of the line, or you will disorientate your viewer.

Don't cross the line
In the second of the lower images, the character moves in the same direction as in the top image (from left to right). This results in a natural flow for the viewer reading the images.

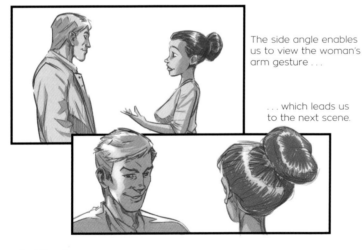

The side angle enables us to view the woman's arm gesture . . .

. . . which leads us to the next scene.

Orient the viewer
Characters can support the rules of orientation even in an unusual panel arrangement. Above, we can see that both figures are making eye contact. This helps us follow the woman's arm, which leads right into the head of the man in the next panel, protruding eye-catchingly out of the panel. The figures have not moved, but the reader's eyes have, which is just as important. It also moves our point of view to help us empathize with the woman, as we are seeing the man from her viewpoint.

The 180-degree rule
It's okay to change the viewing angles between panels (see left), but not the direction of the camera. Choose a side—and stay there.

231 AVOID TANGENTS

In geometry, a tangent is defined as a curved line that touches a straight line without crossing it. This phenomenon can occur (more often than you think!) in drawing, where objects accidentally share outlines. This gives a very unprofessional effect, and will make your drawings seem lifeless and flat.

No touching!
The character's arm shares the same outline as the post. It's easy to do this by accident, so pay attention.

232 USE THUMBNAILS

Good composition requires good planning. Thumbnails are a great way to work up early ideas. The idea is not to define lines at this stage, but to connect with them. You can enlarge your thumbnails later on as a guide when you come to make final drawings.

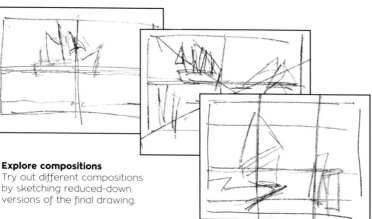

Explore compositions
Try out different compositions by sketching reduced-down versions of the final drawing.

233 USE CONTEXT TO INFORM YOU

It doesn't help to know about a load of techniques if they limit your creative power and storytelling ability. All of the techniques shown here depend on you being able to identify when something looks a bit odd— and make it work better. It's important not to neglect the planning and sketching stages, but most of all, remember to develop your art and tell your story based on your personal style. Don't get stuck on rules and clichés. Be yourself.

POWERING YOUR SCENES

234 USE FRAMING

The ability to tell stories is often even more important than drawing the perfect line—and it can be tricky. You may have a story clear in your mind, but that doesn't mean it's clear in the minds of your audience. Framing is about how you catch the reader's attention and tell your story in a fluent and flowing manner that also looks good. The idea is to give the impression of movement to your scenes through the correct use of "camera" angles.

235 PLACE THE VIEWER

The establishing shot shows the area where the story (or event) is happening. It may be a relatively extensive shot, showing an entire city or a larger location, or it could simply be a room. A broader shot like this always has the intention of showing something to the viewer, providing a location in space and time.

Establishing shot
This establishing shot sets a scene in which anything could happen. From here, your story may begin within the house, the cars, or even with a figure lurking behind the trees.

236 USE LONG SHOTS

A long shot may retain a focus on the character, object, or main subject of the story—the protagonist or even the antagonist. Or it may be used to show an object left in a scene, such as a gun. When people feature in long shots, make sure that they appear completely, or at least from halfway up the legs.

Long shot
Here, we can see a girl with a bicycle in an alley. Even by giving a lot of information about where the action is taking place, she is clearly the focal point in this shot.

237 LOOK FROM THE GROUND

A good way to create visual interest is to position the camera at ground level, as if the viewer were watching the scene while lying on the floor. In this type of shot the ground is often not drawn, and is replaced by the lower border of the panel. Don't overuse this technique—the reader will feel like an ant. However, when used with caution it can be a great way to avoid monotony.

238 GO OFF-PANEL

When we allow one of the characters to break out of the panel, they come out of the story to meet the viewer, making for an interesting effect. This is a technique specific to comics, as a way to create an immediate 3-D effect.

239 USE MEDIUM SHOTS

In a medium shot, we seem to approach the character (or object) that deserves special attention in a particular scene. The character is almost always shown as the top half only, cut across the stomach. Think about the rule of thirds, and make sure there is sufficient space above the character's head.

Medium shot
The man in the foreground establishes that he is our focal point of the story.

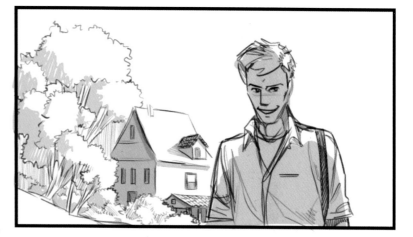

PROPS AND STAGING, BY MARK A. ROBINSON

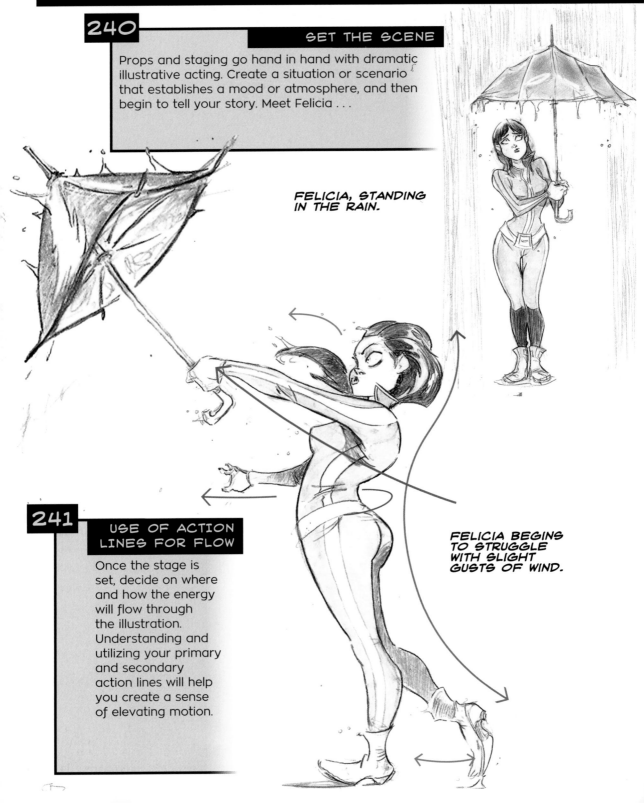

240

SET THE SCENE

Props and staging go hand in hand with dramatic illustrative acting. Create a situation or scenario that establishes a mood or atmosphere, and then begin to tell your story. Meet Felicia . . .

FELICIA, STANDING IN THE RAIN.

FELICIA BEGINS TO STRUGGLE WITH SLIGHT GUSTS OF WIND.

241

USE OF ACTION LINES FOR FLOW

Once the stage is set, decide on where and how the energy will flow through the illustration. Understanding and utilizing your primary and secondary action lines will help you create a sense of elevating motion.

242

PUSH THE NARRATIVE

With the action established, you are free to pull out the stops and go for an extreme action. Use this movement as the middle point to enhance the dramatics of your illustrative storytelling. "Giving something the business" is an old animation term I learned some time ago that defines this type of creative ideology in any kinetic drawing. Push the motion in your illustration and you push the acting, which ultimately helps push the story along.

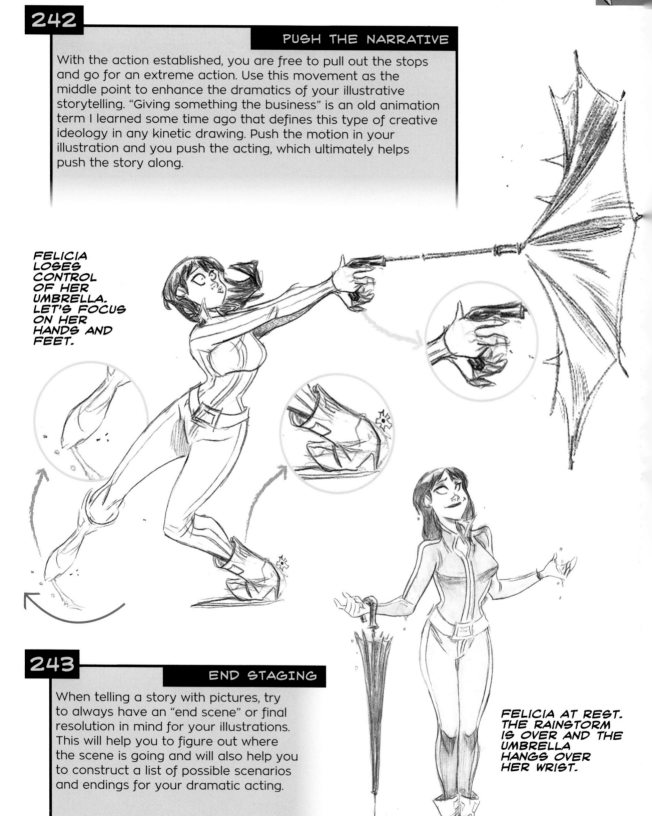

FELICIA LOSES CONTROL OF HER UMBRELLA. LET'S FOCUS ON HER HANDS AND FEET.

243

END STAGING

When telling a story with pictures, try to always have an "end scene" or final resolution in mind for your illustrations. This will help you to figure out where the scene is going and will also help you to construct a list of possible scenarios and endings for your dramatic acting.

FELICIA AT REST. THE RAINSTORM IS OVER AND THE UMBRELLA HANGS OVER HER WRIST.

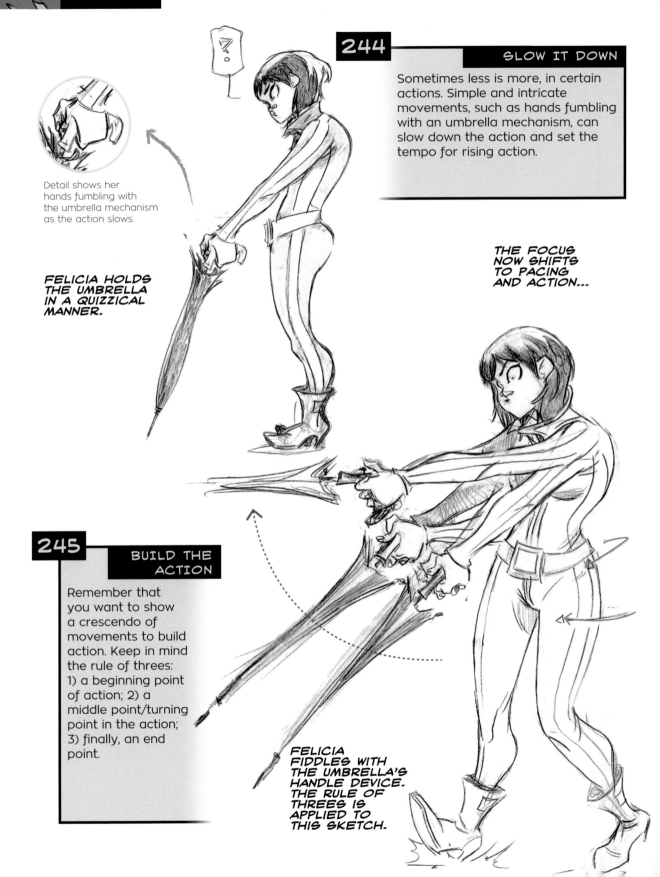

Detail shows her hands fumbling with the umbrella mechanism as the action slows.

FELICIA HOLDS THE UMBRELLA IN A QUIZZICAL MANNER.

244

SLOW IT DOWN

Sometimes less is more, in certain actions. Simple and intricate movements, such as hands fumbling with an umbrella mechanism, can slow down the action and set the tempo for rising action.

THE FOCUS NOW SHIFTS TO PACING AND ACTION...

245

BUILD THE ACTION

Remember that you want to show a crescendo of movements to build action. Keep in mind the rule of threes: 1) a beginning point of action; 2) a middle point/turning point in the action; 3) finally, an end point.

FELICIA FIDDLES WITH THE UMBRELLA'S HANDLE DEVICE. THE RULE OF THREES IS APPLIED TO THIS SKETCH.

246

EXAGGERATE FOR EFFECT

Push the extremities and exaggerate your illustrations. "Give it some business" (see tip 242) and don't be afraid to warp one action into another in order to articulate an extreme action or moment in your acting/storytelling.

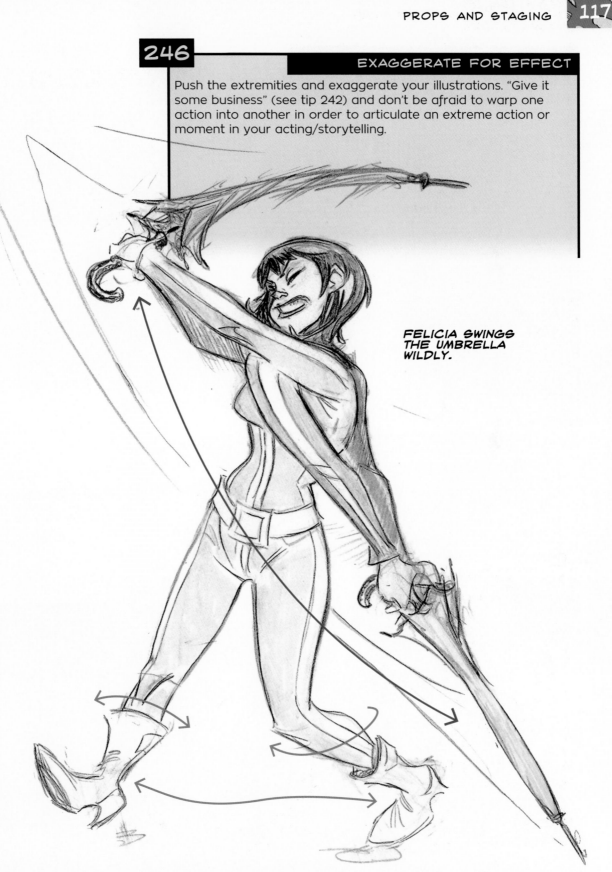

FELICIA SWINGS THE UMBRELLA WILDLY.

USING PROPS TO CONVEY ACTION, BY MARK A. ROBINSON

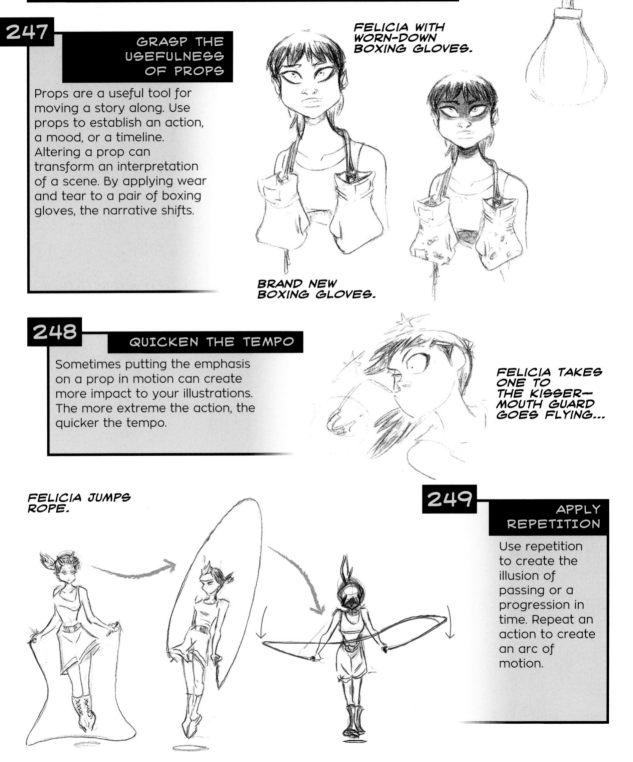

247 GRASP THE USEFULNESS OF PROPS

Props are a useful tool for moving a story along. Use props to establish an action, a mood, or a timeline. Altering a prop can transform an interpretation of a scene. By applying wear and tear to a pair of boxing gloves, the narrative shifts.

FELICIA WITH WORN-DOWN BOXING GLOVES.

BRAND NEW BOXING GLOVES.

248 QUICKEN THE TEMPO

Sometimes putting the emphasis on a prop in motion can create more impact to your illustrations. The more extreme the action, the quicker the tempo.

FELICIA TAKES ONE TO THE KISSER—MOUTH GUARD GOES FLYING...

FELICIA JUMPS ROPE.

249 APPLY REPETITION

Use repetition to create the illusion of passing or a progression in time. Repeat an action to create an arc of motion.

FELICIA IN HER CORNER, ON THE ROPES. (NOBODY PUTS FELICIA IN THE CORNER!)

250 KEEP IT CONSISTENT

Prop consistency helps to give character and mood to an illustration. Time and motion can be defined through the breakdown and build up of props. For example, consider the difference of the possible stories behind a sink full of dirty dishes versus a dish rack filled with clean ones.

251 CREATE ANTICIPATION

Use props to establish a sense of building tension, and to give the illusion and intention of an action about to occur. The interaction of props can create more flair and drama in your illustrations, which can also help push a story or scene along.

FELICIA LOOKS READY TO POUNCE. SEE HOW SHE'S GRIPPING THAT STOOL.

FELICIA PULLS THE TAPE FROM HER FINGERS. THE FIGHT IS OVER.

252 REUSE PROPS TO BUILD THEMES

Reoccurring props can be used as story devices to help define themes for your illustration's drama. Themes create questions like, "Where is the story going?" and "Where has it been?"

MARK A. ROBINSON

Hi, my name is Mark A. Robinson. I got started in comic book illustration 15 years ago with Vertigo Comics. I have continued my work and study through illustration, animation, and comics. Now I am working a day job and moonlighting as a cartoonist at night.

Objects around a primary image can evoke a sense of movement.

QUESTIONS & ANSWERS

WHAT IS YOUR FAVORITE MEDIUM, AND WHY?
Good old-fashioned pencil lead and Bristol board paper. Nothing feels more authentic and organic to me.

NAME AN ILLUSTRATOR YOU ADMIRE:
Will Eisner. Jack Kirby. Ralph Bakshi. Chuck Jones.

WHAT INSPIRES YOU?
Jazz. Baseball. My studio space.

DESCRIBE YOUR STYLE:
I've heard "Dirty Disney" and "Dirty American Anime" before. I like to think of myself as a cartoonist who can illustrate stories.

Create lines of action that move in constant opposition to one another.

MY ART TIPS

253 Placing objects around a primary image can simulate a sense of movement. It can also help the human eye move around an image to "trick" the viewer into feeling the sense of motion in your drawings.

254 Try to create lines of action that move in constant opposition to one another, yet circle around the primary image to create added motion. This is called primary and secondary action.

255 Use the power of exaggeration in your drawings to create added movement. Learn squash and stretch techniques. Elasticity creates a sense of dynamic movement as well.

256 Use sound effects to create a sense of excitement. A well-placed "Zing" or "Pow" can elevate any illustration to evoke a more dynamic moment. It can help denote a starting or ending point to an action drawing.

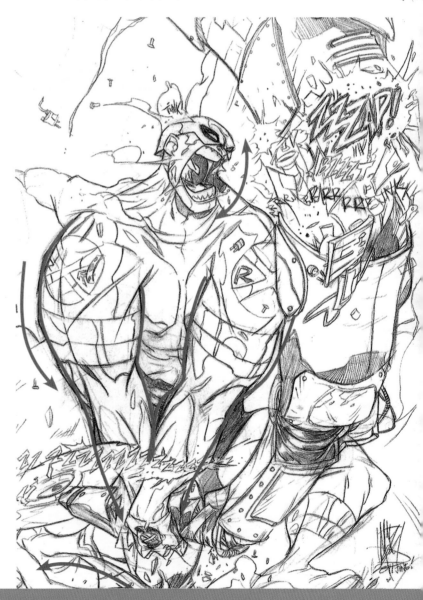

JASON CHATFIELD

I've been a professional cartoonist for 12 years, which makes me a little tadpole among my colleagues. I was born in Perth, Australia, and now live and work from my studio in New York. My work is published daily in over 120 newspapers in 34 countries in the iconic comic strip, *Ginger Meggs*.

QUESTIONS & ANSWERS

WHAT IS YOUR FAVORITE MEDIUM, AND WHY?
Brush pen on paper is my favorite at the moment. I always carry a little sketchbook and pen in my pocket wherever I go to sketch things I see—there's something about the spontaneity of it that I find hard to recreate digitally.

NAME AN ILLUSTRATOR YOU ADMIRE:
I really admire Jack Davis, particularly his working attitude. He's never been difficult or a pain to work with, and he manages to turn out some of the greatest work in commercial illustration. He is attentive about his work for commercial clients—if it isn't right, he tosses it and starts again.

WHAT INSPIRES YOU?
Seeing other artists younger than me who draw way better. It used to make me feel jealous, but now I realize that it means there's a future generation of artists coming through to sustain the industry. Seeing their work makes me work harder.

DESCRIBE YOUR STYLE:
It's a chaotic pastiche of John K/Bob Camp's Spümcø style from *Ren & Stimpy*, Disney animation, Mort Drucker, and the Usual Gang of Idiots at *MAD Magazine*.

Decide if your vehicle needs to be fast or slow.

Keep your pencil lines spontaneous.

If it helps—especially to convey speed—draw the line of motion.

MY ART TIPS

257 The most important question I find myself asking when drawing movement is "What is the intention of the action?" There are many angles and ways to draw the same motion, but if you understand what the intention of the movement is, it removes a lot of variables from the visual equation.

258 Always sketch out a few different angles, and once you've established a line of "intention" or a "motion path" (depending on how you were trained) settle on your action drawing and make sure you know where the weight is flowing.

259 Think of the physics of the object or character you're drawing. Is it clunky and slow? Jiggly and bouncy? Sleek and swift? If you need to literally draw the line of motion to indicate the path of the object, sometimes that is absolutely fine. And don't labor over it—too many lines confuses good movement. Try to retain the spontaneity of your pencil lines.

VALUABLE RESOURCES

1. RECORD WITH A CAMERA

If I need to check something simple—like the correct position of a clenched fist, for example—I use my phone camera, take a picture, and use it as reference for my drawings. Whether you choose a conventional camera or your smartphone, having a camera ready at all times is a great tip for any artist.

2. LOOK IN A MIRROR

A wall mirror is really useful, especially if you can see your whole body. Struggling to draw a pose? Use the mirror. Trying to show grief, joy, or disappointment? Use the mirror.

3. DELVE INTO FAMILY PHOTOS

If there is more than one person involved in a pose, turn to your family photo album. Look for pictures showing several different people, their behavior, how they hug each other, their smiles, and how they share a moment of happiness. If you're searching for reference for clothing, you can also find great historical details.

4. TURN TO SOCIAL MEDIA

If family photos don't have what you're looking for, social media sites can be a good place to look—try your own networks, or those of friends.

5. WATCH MOVIES

Do you need inspiration for action scenes? Do you need to research a medieval dress or a futuristic scenario? Or maybe you need inspiration for a dialog scene between people in an office. Movies can make great reference sources for these scenarios. Just as a director needs to choose the best angles, environments, lighting, and props to tell a story, so should you.

6. SEARCH THE WEB FOR BACKGROUNDS

Hardly any artists draw background scenery without references. The web is an excellent reference source for backgrounds—from anywhere in the world. Just try running an image search in your browser. You can also use tools such as Google Street View or 3-D apps such as SketchUp (great for checking how an object looks from different angles).

7. TAKE LIFE DRAWING CLASSES

Learning about the human figure through books is great, but it's even better to learn from real life. In addition to the immersion in the subject that the environment provides, you also get the chance to network with other artists.

8. KEEP A PERSONAL SKETCHBOOK

A sketchbook is one of the best ways of recording things you see when you are not drawing at home or in your studio. Regular use also makes you faster and more accurate. You can use it as a tool to record your ideas, and observe their evolution through the pages. Choose from a real sketchbook or a sketchbook app on your smartphone or tablet.

9. STUDY ANATOMY BOOKS

This book does not claim to serve as an anatomical encyclopedia. For a deeper study of anatomy, keep a solid anatomy book by your side; preferably one aimed at artists. There are loads of amazing books on this subject, for example those by Burne Hogarth, George Bridgman, or Michael Hampton. Find what you like best.

10. STUDY ANIMATION

The main purpose of animation is to convey reality in a slightly distorted way, and yet in such a way that it is much more interesting and plausible than real life itself! *Cartoon Animation* by Preston Blair and *The Animator's Survival Kit* by Richard Williams are among the best books of their kind if you want to go deeper into the subject.

11. READ COMICS

Comics are sometimes known as the ninth art (after architecture, sculpture, painting, dance, music, poetry, cinema, and television). I grew up reading comics. They were the first contact I had with literature. Comics are the reason I started getting interested in art in general, and decided to become an artist. Dozens of my favorite artists are comic artists. Regardless of the comic style you prefer (such as American, European, or Manga), comics are a fantastic resource for the study of storytelling. Read them!

12. EMULATE YOUR FAVORITE ARTIST

Most great artists cite other great artists as influences. When we enjoy the style of an artist it is natural to emulate their style to some extent, even if unconsciously. There is nothing wrong with that—on the contrary, it's a great way to measure your own progress. Obviously, you do not want to turn out exact copies. But with practice and the necessary dedication, you will start to develop your own style . . . and guess what—you will become the favorite artist of someone in the future!

13. BECOME AN ACTOR

How can you improve the expressions of your characters—the way they react to fear, surprise, happiness, sadness, or anger? Well, every good artist is also a great actor. Before attempting to convince your audience of what your character is feeling, try to convince yourself first! You may even benefit from acting classes. Break free of prejudice; be an observer, not a critic.

14. BE SELF-CRITICAL

You need to focus on evolving, seeking challenges, and trying to go beyond what you consider your comfort zone. Listen to criticism from people who are not related to you (your mother will always say that you are the best artist in the world). Show your work to industry professionals and publish your portfolio on the Internet for others to judge. Look for other influences, other ways to expand your art, other materials you can use on a daily basis. The key is to never settle for the status quo. The market is extremely competitive, but also very diverse. Take every opportunity to invest in your career.

INDEX

CREDITS

This book is dedicated to the following people:
To my dear wife, Fernanda, for understanding my absence when I was dedicated to making this book. To my beautiful daughter, Mariana, for bringing moments of joy to our lives and for being a Godsend. To my dear mother, Candida, for all the support, care, and dedication during every moment of my life (and for buying my comics, of course). To my dad-hero, Alcy, for teaching me to be strong and humble and to never lose my sense of humor, even in the most difficult moments of life. To my aunt, Marilia, who always believed in my potential as an artist and encouraged me to get ahead. To my great friend, Stanley, for his optimism and for putting up with me all this time—without grumbling.

Special thanks to my editors Kate Kirby and Katie Crous, for all their care (and patience), and for the invitation to go on this incredible journey. Thank you to all the extremely talented people at Quarto Publishing for being responsible for bringing this book to life.

I can't finish without thanking all of the guest artists (some of whom are my idols) who agreed to participate on this book, contributing their fantastic artwork and valuable tips.

And finally, I would like to thank you, the reader, for buying this book and for giving me the opportunity to contribute a little to your professional growth. Thank YOU!

Quarto would like to thank Brian Douglas Ahern for providing additional and revised text where needed.

We would also like to thank the following artists for contributing to this book:
Laura Braga, pp. 38–41
Jason Chatfield, pp. 122–123—*Ginger Meggs* ©
 Copyright Jason Chatfield, TM Winslow Investments
 Pty Ltd.
Louis Decrevel, pp. 100–101
Elisa Ferrari, pp. 98–99
Jonathan Hill, pp. 70–71
Dennis Jones, pp. 42–43
Donna Lee, pp. 96–97
Sonia Leong, p. 63
Brittany Myers, pp. 68–69
Mark A. Robinson, pp. 114-119, 120–121—*Felicia* ©
 Copyright Mark A. Robinson and Kel Symons.